IMAGES
of America
CORONA

D1604281

Mary Bryner Winn

Published by Arcadia Publishing
Charleston SC, Chicago IL, Portsmouth NH, San Francisco CA

Printed in Great Britain

Library of Congress Catalog Card Number: 2005293145

For all general information contact Arcadia Publishing at:
Telephone 843-853-2070
Fax 843-853-0044
E-mail sales@arcadiapublishing.com
For customer service and orders:
Toll-Free 1-888-313-2665

Visit us on the internet at http://www.arcadiapublishing.com

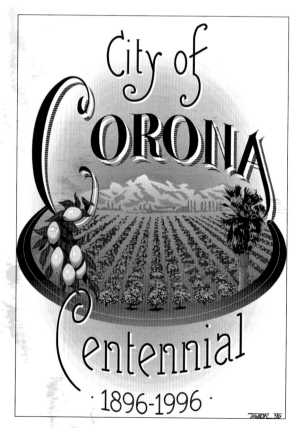

Corona's centennial seal was created in 1996 by Corona graphics designer Ted Taylor. The city was founded as South Riverside in 1886 and was incorporated and renamed Corona in 1896. (Courtesy of City of Corona.)

CONTENTS

ACKNOWLEDGMENTS

Working on this book has been a truly memorable experience and has helped me develop an even stronger bond with the remarkable city I have called home for 29 years.

Thanks to the board of directors of the Corona Historic Preservation Society for their encouragement and for showing confidence in me in the undertaking of this project. Heartfelt appreciation must also be extended to the board of trustees of the Corona Public Library for their generosity and unanimous support. Great appreciation is also extended to Corona Public Library director Howard Curtis and the staff of the Heritage Room, namely Chris Tina Smith, Sandra Falero, Jennifer Marlatt, and Vera Garcia for their collaboration and invaluable assistance. Many thanks go to longtime Coronans Phil Newhouse and Tony Rodriguez, who provided wonderful insight and interesting tidbits to enrich the captions contained herein. I would also like to thank Ted Taylor of Corona Heritage Park and Museum, local photographer Eugene Montanez, and city clerk Vicki Wasko for sharing their images with me. Appreciation goes to the Corona City Council for allowing me to include the city's centennial seal and to my dear friend Mary Jo Boller, who assisted with the editing of the text. Last but not least, I must express my gratitude to my husband, Richard, for being so patient and helpful as this book has evolved.

INTRODUCTION

Corona, California, is located approximately 45 miles southeast of Los Angeles in western Riverside County. Corona is at the base of the Cleveland National Forest on an alluvial plain leading down to the Santa Ana River. Founded in 1886, it was known as South Riverside until 1896 when it was incorporated and renamed Corona.

The first inhabitants of the area were the Luiseño Indians, who were hunters and gatherers. They hunted throughout the area for black bear, snakes, rodents, rabbits, coyote, birds, and fish. They used the wild grasses for baskets, constructed clay containers from the abundant clay soil, and gathered local acorns, seeds, berries, and roots for food. They bathed daily in the hot waters in Temescal Canyon, the area known today as the Glen Ivy Resort. The remains of their artistic pictographs and petroglyphs can still be found in areas south of Corona.

The Luiseños came under the influence of Spanish settlers during the first part of the 19th century and as settlement progressed inland the land was soon taken over by Spanish ranchos. Sheep and cattle dotted the hillsides of the ranchos of the Serrano, Cota, Sepulveda, and Botiller families. Leandro Serrano, the first of the Spanish settlers in Riverside County, arrived in the Temescal Valley in 1818 and established his rancho approximately one mile north of Glen Ivy the following year. In 1838, Juan Bandini took possession of the Prado Basin land and started a cattle and sheep ranch there.

Prior to 1886, the Corona area had been a rock-strewn, brush-covered terrain with no trees. The predominant inhabitants were jack rabbit, quail, sheep, and coyote. Water was scarce. The great boom of the 1880s was in full swing in California. Robert B. Taylor, a land speculator from Sioux City Iowa, envisioned the transformation of this desert area into a thriving community surrounded by a "round road." In 1886, he persuaded fellow Iowans Adolph Rimpau, George L. Joy, A. S. Garretson, and former Iowa governor Samuel Merrill to join him to form the South Riverside Land and Water Company. Together they raised $110,000 and purchased roughly 12,000 acres of agricultural land from the Yorba Ranch. Taylor hired H. Clay Kellogg, an Anaheim engineer, to survey and design the three-mile long, circular Grand Boulevard and thus South Riverside or the "Queen Colony" was born.

Taylor, who had been named manager of the South Riverside Land and Water Company, realized that water would be the lifeblood of their new community and made certain additional money was set aside for the acquisition of adequate water rights to the area. A few artesian wells were available and pipes eventually brought water from a variety of sources, including Lake Elsinore some 20 miles away.

The Santa Fe Depot was built in 1887 just north of the town site to provide transportation for those wishing to migrate to the area. That same year railroad fares from Kansas to Los Angeles dropped to an unprecedented $1 per person.

The Victorian Hotel Temescal was built to provide lodging for visitors and for new property owners waiting for the construction of their homes to be completed. Early leaders planted trees and donated valuable land to churches. Stores and businesses were established to provide needed goods and services for the fledgling community. Education began with a one-room schoolhouse. By 1889, a stately school for all grades was in place.

Within a few years, South Riverside became a highly desirable community. The success was due to the existence of rail transportation into town, the availability of affordable land and water, and hard-working residents determined to transform a desert into a garden. Corona's relatively frost-free climate and rich soil were found to be quite conducive for raising citrus crops. Envisioning future profits, almost all the new settlers planted orange and lemon trees. The first orange bud grew behind the Hotel Temescal and the first oranges were shipped in 1893.

Grand Boulevard was the center of Corona and early residents liked to parade their fancy buggies along the street, which encircled the heart of the community: its schools, churches, residences, and businesses. Manufacturing plants and packing houses were located to the north along the railroad tracks. The southern end of town was left to the citrus industry. Lastly, mining interests were developed just outside the city's southeastern and eastern city limits.

On July 13, 1896, the residents of South Riverside voted to incorporate their city and change the name to Corona, Spanish for "crown," in honor of the city's circular Grand Boulevard. By 1900, Corona's population numbered 1,434.

The population continued to grow as Italians from Sicily were recruited to share their citrus growing expertise and brought their families with them. Hispanic workers, mainly from Mexico, became the workforce largely instrumental in the expansion and development of the local citrus industry. Eventually, citrus groves stretched from the south side of Grand Boulevard to Chase Drive and beyond to the Cleveland National Forest boundary. Some of the early pioneers who planted citrus in Corona were W. H. Jameson, A. F. Call, S. B. Hampton, John Flagler, and Ethan Allen Chase.

By 1920, Corona boasted 11 packing houses in which fruit was washed, sorted, stored, and boxed to be shipped throughout the world. For convenience in loading and unloading, packinghouses lined both sides of the railroad tracks north of Grand Boulevard near the Santa Fe Depot.

These pages offer a few glimpses of the early community of Corona, the people and places, and the events that influenced the type of town it has become. Readers who would like to learn more about Corona's past can investigate the archives and collections at the W. D. Addison Heritage Room of the Corona Public Library and at the Corona Heritage Park and Museum.

One

THE EARLY YEARS
1886–1900

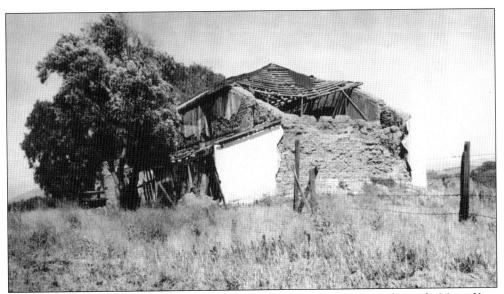

This two-story adobe was built in 1841 and was home to Leonardo Cota, his wife, Marie Ynez Yorba Cota, and their six children. Rumor had it that gold was incorporated into the mud of the adobe. Because of this, the remains were plundered by people literally searching for gold in the walls. The original of this 1936 photograph is on file at the Library of Congress.

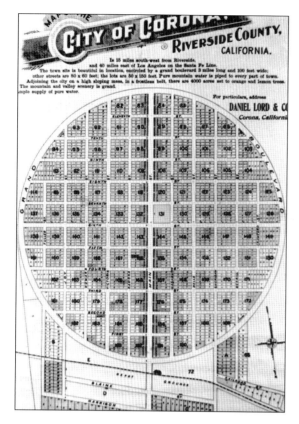

A map of South Riverside in 1886 shows how civil engineer H. Clay Kellogg laid out the one-mile-diameter circle and platted out the lots. The map is oriented with north at the bottom. Early on, the founding fathers envisioned the circle being used for horse racing to make the city famous. Little did they know at that time that auto racing would put the city on the map.

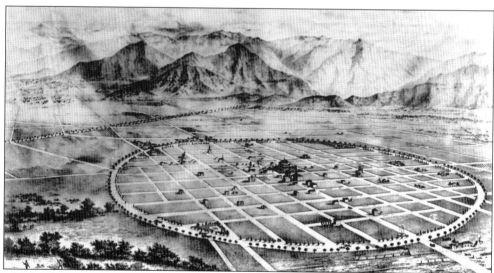

This bird's-eye view of South Riverside looking south was commissioned by Robert B. Taylor and shows the town as it appeared in 1887, shortly after the colony was founded by Taylor, George L. Joy, Adolph Rimpau, former Iowa governor Samuel Merrill, and A. S. Garretson. Civil engineer H. Clay Kellogg was hired to design the circular Grand Boulevard and to survey and lay out the new colony.

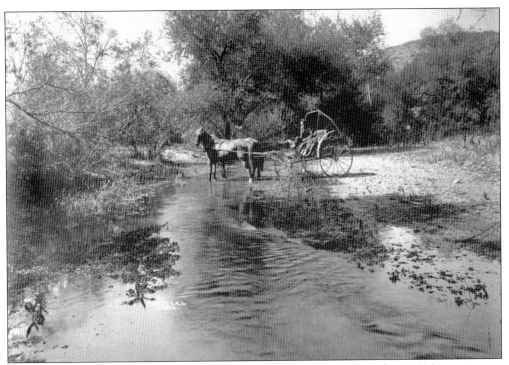

A horse and buggy travels along Temescal Creek south of South Riverside in 1886.

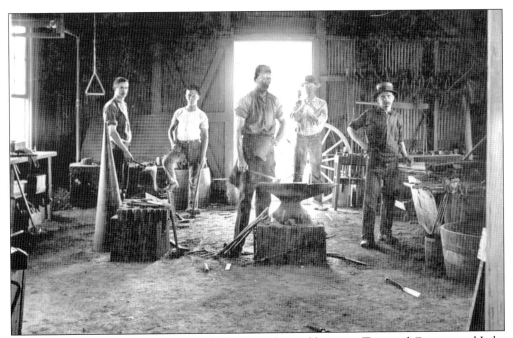

Around 1891, the Tin Mine Blacksmith Shop was located between Temescal Canyon and Lake Mathews. Various metalworking tools are seen in the shop.

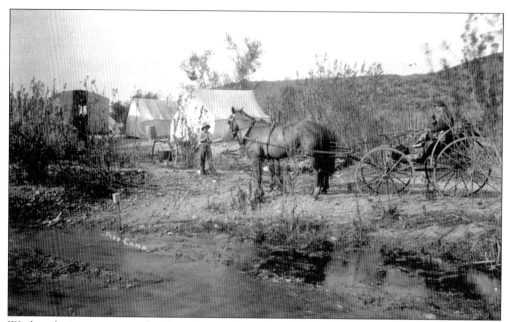

Workers laying water pipe lived in this "pipe camp" in Temescal Valley for the duration of the project. The word Temescal is of American Indian origin and means "sweat house." This image was taken in 1886.

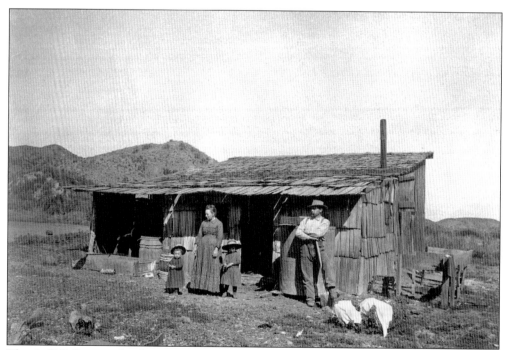

The A. F. B. Lawson family pose in front of their Hagador Canyon home in 1887. The canyon was an early source of water for the foundling community and at one time contained a lime kiln. The canyon was named after Mr. Hagador, who built the house, which is typical of the type of cabins found in the areas surrounding Corona prior to its founding as South Riverside.

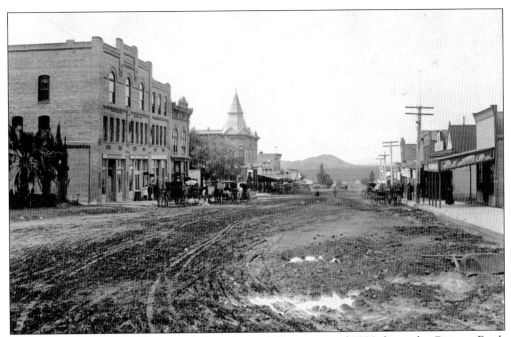

A view of Main Street looking north from Seventh Street around 1888 shows the Citizens Bank with its landmark cupola in the center. On the right, a sign reads "Iowa and California Land Co." On the left are two signs, one for Clayson and Scoville and another for Corona Restaurant and Bakery. In this image, Main Street extends north into the alfalfa fields only as far as River Road. Beacon Hill is in the background.

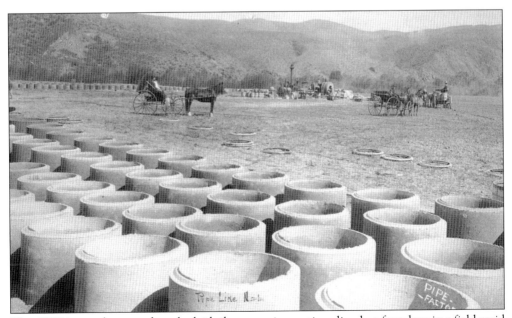

This 1887 image shows ready-to-be-laid tile water pipe sections lined up four deep in a field amid horses and buggies in Temescal Canyon. Over the years these pipes brought much-needed water to the citizens of South Riverside and then Corona as well as to many acres of citrus groves.

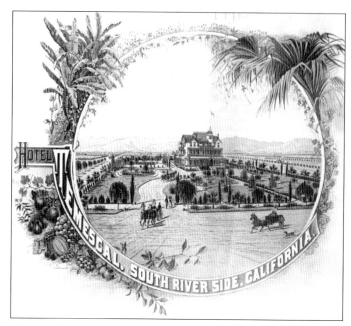

Hotel Temescal was initiallly located near Seventh and Washburn, approximately where the Corona Public Library stands today. It was built by Orlando A. Smith at a cost of $38,000 on land donated by A. S. Garretson and, as the drawing shows, was surrounded by spacious and beautifully landscaped grounds. The building occupied a square block in the center of town and contained 40 rooms, spacious parlors, dining rooms, a large kitchen, and back porches. The first orange tree in the colony was planted here in 1887.

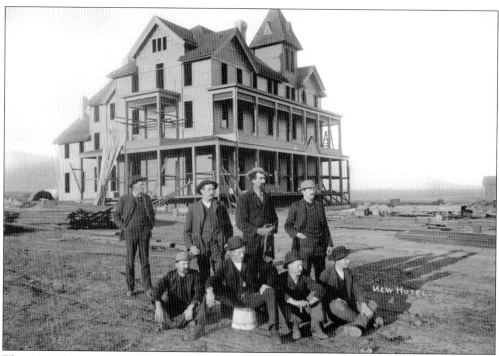

This 1887 photograph shows the Hotel Temescal under construction. Corona's founding father Robert B. Taylor is at the left. In September 1898, the hotel was purchased by J. T. Burton, who spent $4,000 to move the hotel to the northwest corner of the block. During the move, a chimney cracked unnoticed. When a fire was lit in 1899, flames escaped into the walls and destroyed the landmark hotel.

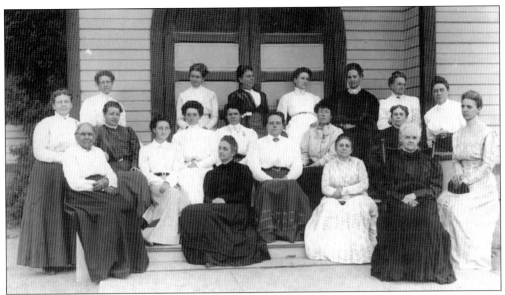

Among the 20 women standing on the steps of the First Baptist Church sometime during the 1890s are Hetty Mary Joy Jameson (standing second from right), Mrs. Beebe (standing third from left), and "Aunty Wilson," (first seated person on left). The church was organized in 1891, and the original wood frame edifice shown here was destroyed by fire in 1937.

The original First Baptist Church was modeled in a Victorian style that incorporated an elaborate square bell tower, arched doors, fish scale shingles, and arched stained-glass windows. Built at a cost of nearly $4,000, it remained in use for over 40 years. On Sunday morning, January 24, 1937, fire destroyed the main building. Soon after, it was replaced with the present sanctuary at the northwest corner of Eighth and Main Streets.

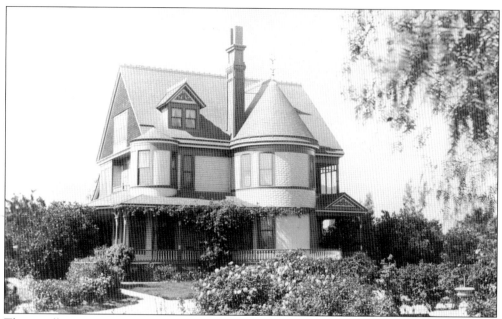

This excellent example of a shingle-style Victorian was built around 1890 by city founder George Lewis Joy at 1127 East Grand Boulevard. Some time later, Dr. Bernice Todd had the second story and attic removed. Feeling the house was too large for her to care for, she decided to downsize the house instead of moving.

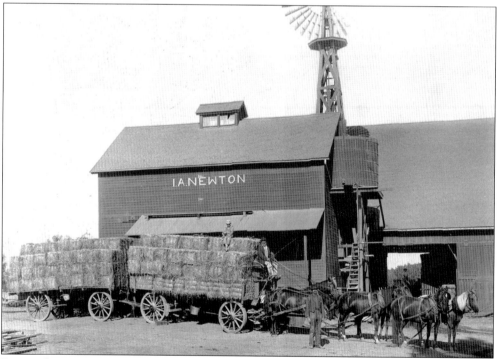

During the 1890s, Mr. A. Newton owned the Newton Hay and Feed Store located east of North Main Street near the middle of Harrison Street. The catchy phrase "Flour, Feed, Fuel" appeared in a newspaper advertisement in 1909. A barefoot boy and a dog sit atop the hay.

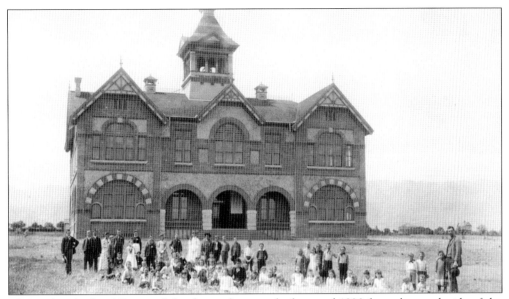

The student body of Corona School was photographed around 1890 from the north side of the property, just a year after the school was built for $20,000. This was Corona's only school and included all grades. It was renamed Lincoln in 1911, shortly after the second grammar school, Washington, was built. In 1913, the second floor and bell tower were removed because of safety concerns and another horseshoe-shaped building was added to the campus.

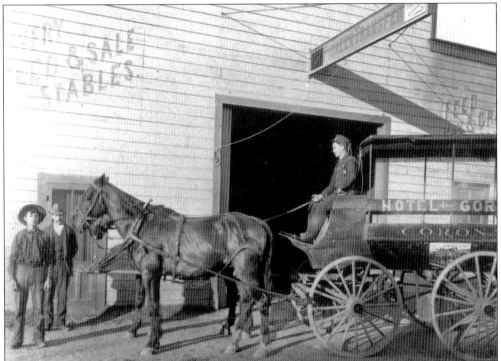

This c. 1890s horse and buggy was called a "free bus" during the early years. The "bus" met all arriving trains both day and night at the Santa Fe Depot and transported the passengers to their destinations. The photograph on the side of the bus above the wheel is the Hotel Temescal.

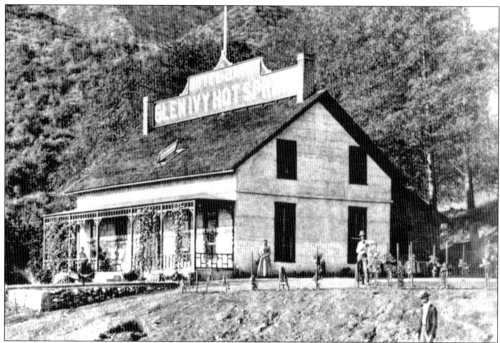

The Glen Ivy Hot Springs Hotel, pictured around 1890, was built by a Mrs. Thorndyke, who homesteaded on property around the springs in the early 1870s and built the hotel and a bathhouse. The Steers family purchased the hotel in 1887 and renamed it "Glen Ivy" for the profusion of ivy growing in the nearby canyon. Over the years, the celebrities and dignitaries who have partaken of the waters at Glen Ivy have included Paul Muni, W. C. Fields, and Presidents Roosevelt, Hoover, and Reagan.

Here is an idyllic scene of the quaint Rugby School, a one-teacher school built in 1889 in Temescal Canyon, south of Corona. As was the fate of many buildings during that time, the school was destroyed by fire in 1919. In the foreground on the left is the hitching post for tying up horses, and to the right of the school is the outhouse.

Two young women with their bicycles set off for a ride, c. 1900. Bicycles were a common mode of personal transportation at the turn of the last century.

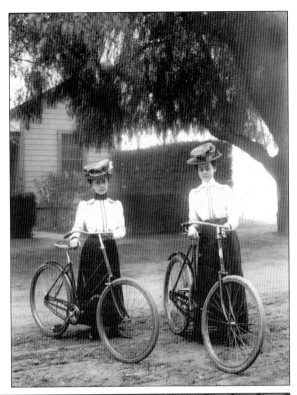

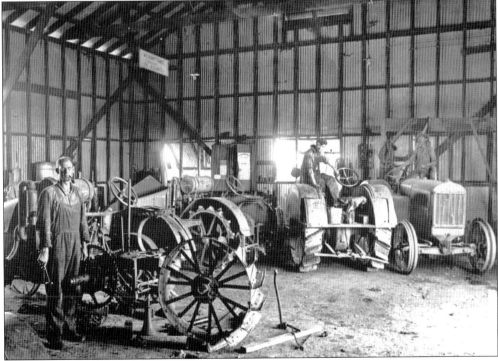

These men are working on steel-wheeled farm equipment dating from the early 1900s. A century ago, men worked for $3 a day with no room or board.

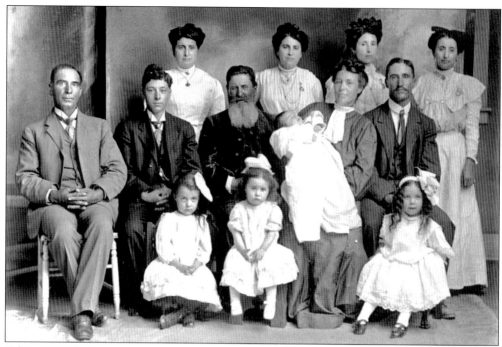

Taken around 1900, this rare family portrait shows a bearded Francisco Serrano surrounded by his large family. Standing in a row behind him are daughters Refugia (Ruth), Beatrice, Clorinda, and Erlinda. Cousin Aguendo Serrano is sitting in front on the far left. Others in the photograph are unidentified. The Serrano family were the first Europeans to settle in Riverside County.

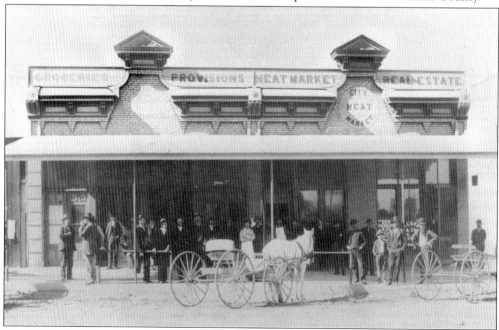

The Taylor Building, located on the west side of Main Street between Fifth and Sixth Streets, was owned by Robert B. Taylor in the early 1890s. Taylor operated his real estate business here. Also pictured is Tuthill's Meat Market.

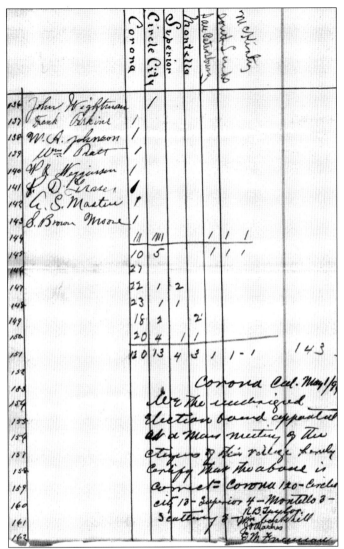

Within 10 years of Corona's founding, the locals had grown disgruntled about being associated with Riverside in the minds of outsiders and believed a name change was in order. This 1896 document shows the final page of the vote tally sheet when South Riverside was renamed Corona. Nominations were made and a new name was voted upon by 143 men. In 1896, when the vote was taken, women were not allowed to vote. Handwritten notes on the lower right read as follows:

Corona, Cal May 14, 1896

We the undersigned Election Board appointed at a May meeting of the citizens of this village hereby certify that the above is correct.

Corona 120, Circle City 13, Superior 4, Montella 3, Scattering 3.

R. B. Taylor, W. H. Corkhill, F. P. Mathis, E.W. Freeman

(Courtesy of City Clerk's Office.)

"Grandma" Tucker, baby Ben Tucker, and a horse are shown in front of their home on Lincoln Avenue near the railroad tracks in this *c.* 1900 photograph. Note the root cellar or basement doors at ground level beneath the gable.

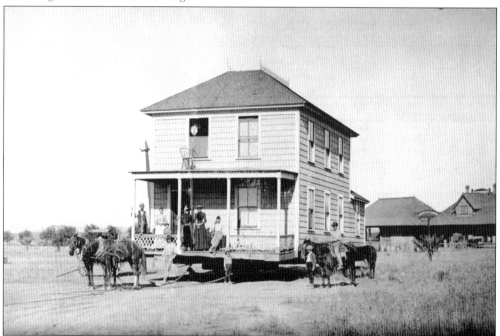

The W. B. Roberds house was built in 1891 was moved from Bluff Street in Auburndale to the northeast corner of Sixth and Victoria Streets. Corona's first Santa Fe Depot, made of redwood, is visible in the background. The family actually lived in the house while it was being relocated. It was once a very common practice to move or relocate structures.

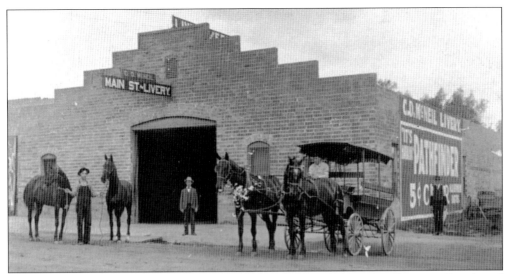

C. D. McNeil (center) operated the McNeil Livery Stable on Main Street between Fourth and Fifth Streets. He served as Corona's postmaster from 1916 to 1925. The building in the picture later housed businesses known as Farmer Air Conditioning and Tin Smithing Company and Newhouse and White Pest Control. A sign advertising 5¢ cigars can be seen on the side.

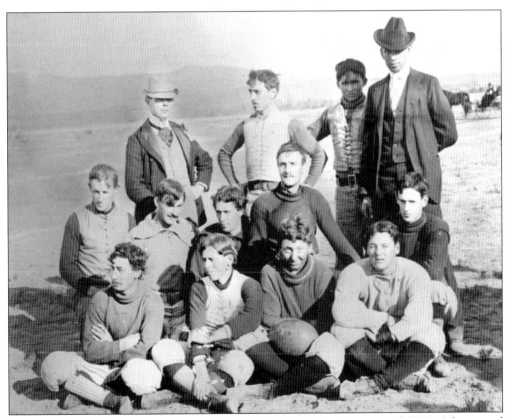

An early Corona football or rugby team poses here with two adults around 1900. A horse and buggy are visible in the background.

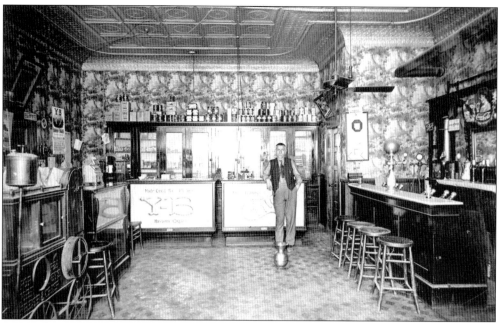

Joe Smith's Cigar Store (complete with a spittoon) is seen here around the early 1900s. The store was located at 110 East Sixth Street. Because of the stools and counter, it appears that some type of liquid refreshment, perhaps Coca-Cola (as evidenced by the sign at far right), was offered in addition to tobacco products. Note the intricate ceiling, wallpaper, and flooring.

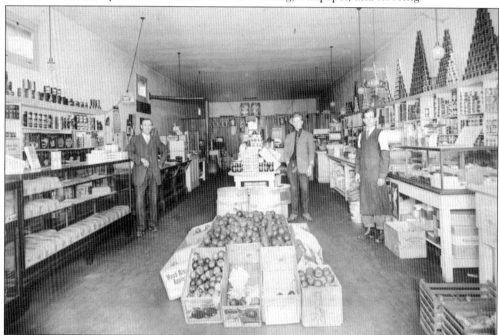

This photograph from the early 1900s shows the interior of a store owned by Harvey and Mary Miller. Located on South Main Street between Fifth and Sixth Streets, it offered bread, fresh fruit, canned goods, and such items as kerosene lamps and hardware products. The only lighting was provided by bare, hanging electric light bulbs.

Banquet

Tendered by Mr. & Mrs. R. B. Taylor

to

The Citizens of Corona, formerly South Riverside,
Riverside County, State of California,

in honor of the

Tenth Anniversary of Town and Colony of Corona

Thursday evening, August 5th, 1897

✳

Menu

Eastern Oysters

———

Chicken Salad a la Mayonnaise
Westphalia Ham

———

Olives	Radishes	Chow-Chow	Salted Almonds

———

Pressed Chicken Parker House Rolls

———

Algerian Punch

———

Manhattan Ice Cream
Angel Cake Lady Fingers Macaroons
Spanish Kisses

———

Peaches	Bananas	Plums	Strawberries

Assorted Nuts and Candies

———

Tea Coffee

This menu is from an elaborate August 1897 banquet hosted by Robert B. Taylor and his wife, Emma. Held at the Hotel Temescal it celebrated the 10th anniversary of the colony's founding and was attended by over 100 Corona pioneers. Besides a sumptuous meal, activities included speeches, toasts, and reminiscences including a statement describing Corona's success as a "progressive and triumphant historical march from a bare uninhabited sheep pasture 10 years ago to a flowering, orange and lemon bearing colony of some 1,500 wide-awake progressive people."

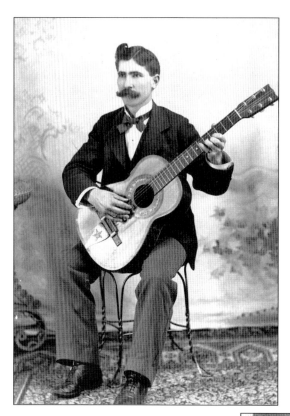

This portrait of Ira W. Misenheimer with a guitar was taken at Farley Portrait Studio in Corona in 1900. For many years Misenheimer worked in various shops as a local barber. A haircut cost 25¢, and a shave was 15¢, according to a 1923 advertisement he placed in the local newspaper.

Glass Brothers Hardware on Main Street measured 15 by 48 feet. Over several decades, brothers Howard and Perle Glass sold hardware, farm implements, windmills, stoves, ranges, laundry outfits, cutlery, guns, ammunition, sporting goods, paints, oils, and brushes. Advertising during that era indicated they did "all kinds of plumbing and tinning."

Two

The Early 20th Century
1901–1940

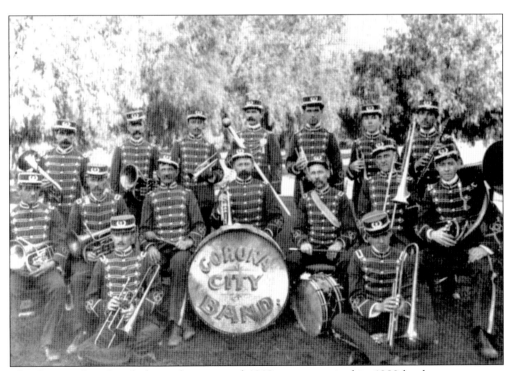

The Corona City Band, shown here around 1902, was organized in 1889 by drugstore owner Rufus S. Billings and was maintained by the city until school bands were organized and became active in the community. The band director was Mason Terpening (third from the right, back row) who was a bank cashier. He also served on the Corona City Council for five months in 1900 and was the city clerk from 1910 to 1924.

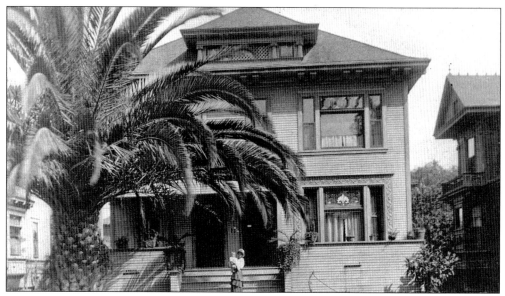

The home of the three Platt sisters, shown here around 1900, once stood at Garretson and East Grand Boulevard. The Platt sisters were middle-aged women when they relocated from Chicago in 1893. Helen was the eldest, then Anna, and Stella. Among their many local accomplishments, the sisters helped establish the Woman's Improvement Club and were instrumental in planting California pepper trees along Grand Boulevard.

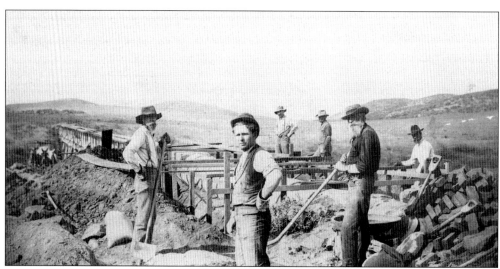

These men are working on a water pipeline c. 1903. Given the area's dry climate, water was critical for agricultural development and the survival of the community. These pipes brought water from as far away as 20 miles.

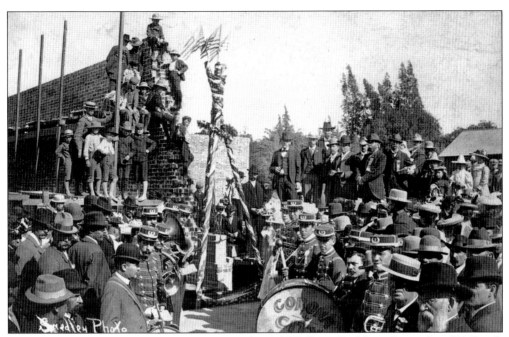

The laying of the cornerstone ceremony at the Odd Fellows Building, located at 614 South Main Street, took place on May 30, 1902, with men in their derbies and women in their bonnets all decked out for the occasion. The Corona City Band is seen in uniform. The structure was demolished in 1969, a casualty of urban renewal.

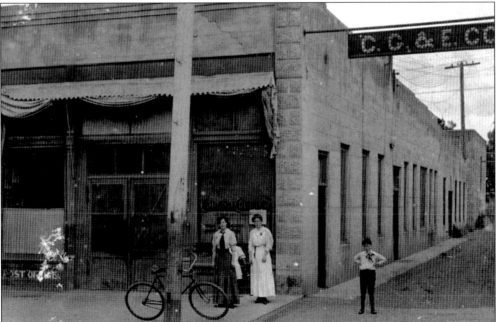

The signs of three Main Street businesses are identifiable in this photograph: the Corona Post Office and *Corona Courier* newspaper on the left, and the Corona Gas & Electric Company on the right. The women in the photograph are Bessie Cook (left) and Elsie Brown, daughter of former postmaster George Brown who built the Corona Post Office on Main Street in 1902.

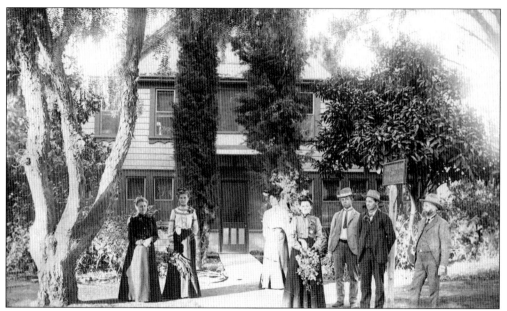

This house at 215 East Sixth Street, photographed in 1902, was both the home and office for John Colby Gleason and his wife, Flora, both medical doctors. John was one of the founders of the First Baptist Church in 1891. He also served as Corona's health officer and had to deal with outbreaks of diseases such as smallpox and typhoid.

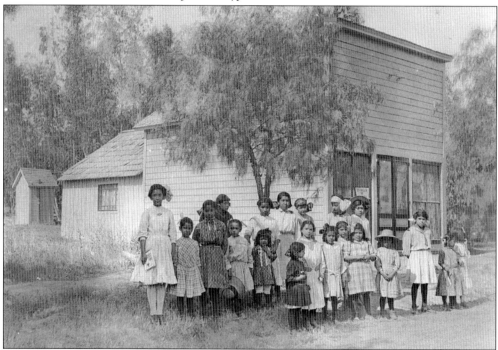

This early 1900s image is of children of the First Baptist Church Spanish Mission being trained by Dr. Flora "Floy" Gleason (Clark) for a Christmas program. The mission was located on Fourth Street between Ramona and Victoria Streets. The outhouse is seen on the left at the rear of the building.

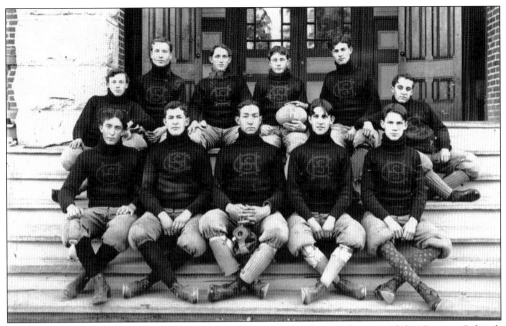

The Corona High School football team, *c.* 1903, poses on the south steps of the Corona School, later known as Lincoln School. It was located on Ninth Street between Victoria and Howard. At the time, it was Corona's only school. The younger students met downstairs, and the high school students met on the second floor.

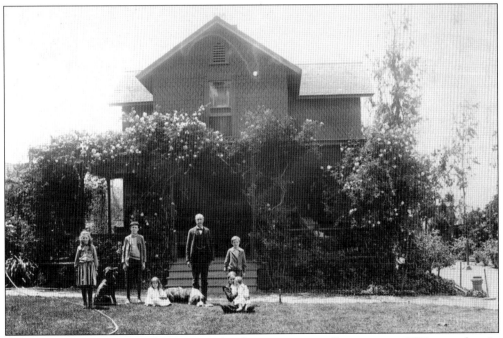

This *c.* 1905 photograph of the Jameson family, prominent in Corona since 1887, was taken in front of their home on the northwest corner of Grand Boulevard and Joy Street. Family members, from left to right, are (standing) Bernice and Joy Gilbert; (seated) Hetty Joy, William Henry II, and William Henry III; (seated) Eloise with baby Adelaide.

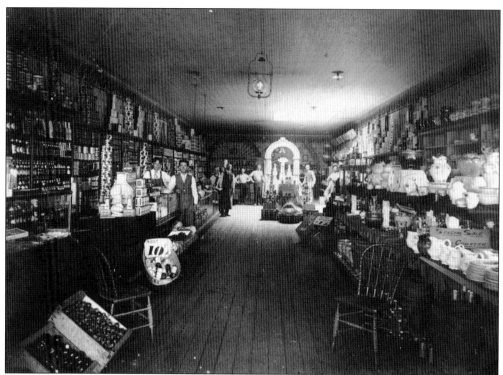

Canned and bottled goods, brooms, crockery, galvanized tubs, footlockers, barrels, and fresh fruit and vegetables were available at Veach and Son Grocery and Provisions, pictured here around 1905. John Veach purchased the store in 1904 from grocers Thacker and Smiley. The building, on the west side of Main Street between Sixth and Seventh Streets, was owned by R. B. Taylor.

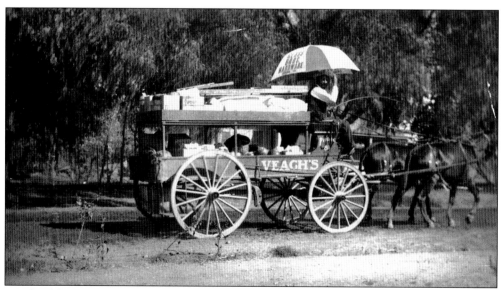

Veach's delivery wagon is seen here in 1905 with the mule team driven by George Allensworth. The wagon delivered food and other commodities to surrounding ranches once a week.

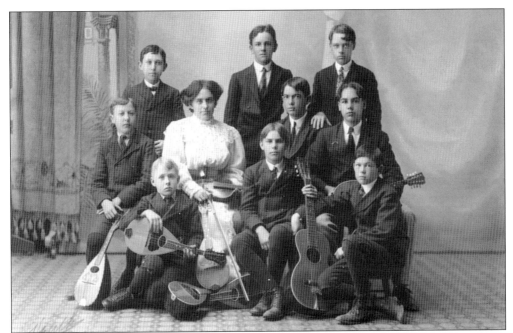

The Mandolin Club, *c.* 1905, led by Miss Dena Cooper, had members who hailed from both Corona and Riverside. In days of yore (the early part of the 20th century) the mandolin shared parlors with zithers and ukuleles and was used to play waltzes, sentimental parlor songs, college songs, light classical music, and marches. Corona's opera house, located at 610 Main Street in the Southern Hotel, hosted many recitals.

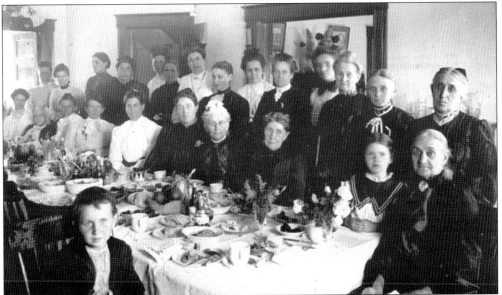

On February 22, 1905, Mrs. Andrew Wheaton (far right) celebrated her 76th birthday in the dining room of the Hotel del Rey. The hotel occupied the southwest corner of Sixth and Victoria Streets and at that time was a social and cultural community center. In 1909, the two-story building was hoisted up and a third floor was added *underneath* the existing structure, making it three stories high.

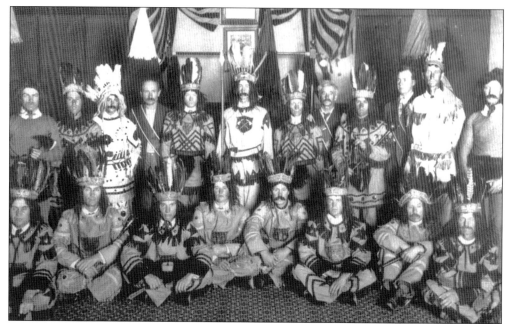

Members of the Corona Red Men Lodge wore elaborate costumes for this 1906 Odd Fellows Hall meeting. The Order of Red Men is chartered by Congress and is a social and political group that is reportedly the oldest American fraternal organization. Corona's lodge was disbanded in the early 1950s.

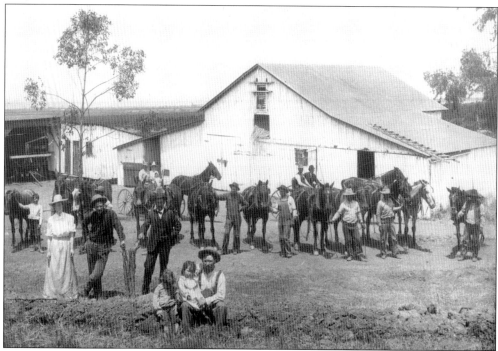

The Ben White ranch was located at the southernmost end of Main Street. This 1906 image shows a variety of ranch hands and families along with their working horses and mules. The man in the black suit may be the ranch owner, Ben White.

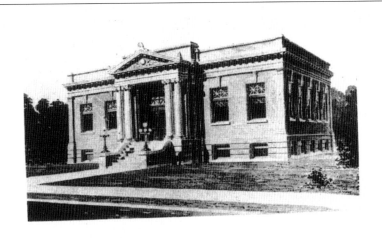

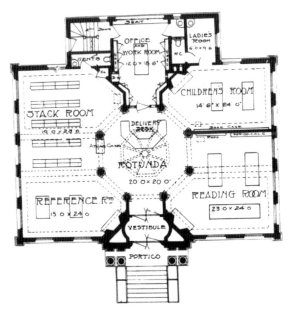

MAIN. FLOOR. PLAN
PUBLIC. LIBRARY. CORONA. CAL.
FRANKLIN. P. BURNHAM. ARCHITECT. LOS ANGELES.

Built with an $11,500 grant from the Carnegie Foundation, Corona's beloved Carnegie Library occupied the southeast corner of Main and Eighth Streets. It celebrated its grand opening on July 2, 1906, and served the Circle City for over 70 years. It was placed on the National Register of Historic Places in 1977. Less than a year later, and in spite of its registry, it was demolished to make way for commercial development. Many Coronans still recall the pile of rubble. Pioneer Chicken purchased the property and intended to build a chicken restaurant. This was never realized, and the property remains vacant to this day. The architectural drawing is of the main floor only, when the library was first constructed. It shows a central rotunda surrounded by a reference room and stack room on the left, offices and restrooms above, and the children's room and reading room on the right. The building also had a basement that eventually became the junior (children's) library.

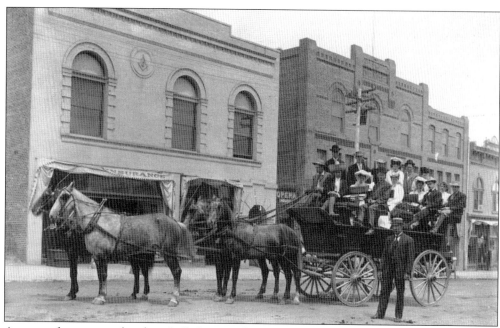

A group of young people take a "tally ho" to Glen Ivy in 1907. A tally ho was a popular mode of transportation and consisted of a buggy pulled by a team of horses. Early Corona High School yearbooks abound with tales of such horse-drawn trips to Glen Ivy and other destinations in the Temescal Valley.

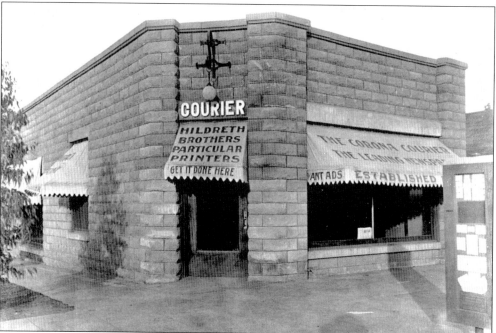

The second *Corona Courier* newspaper building was located at 201 East Sixth Street and was built of cut stone blocks in 1907. Originally founded as the *South Riverside Bee* in May 1887, the newspaper became the *Corona Courier* in July 1896 to reflect the change in the city's name. A subscription in 1913 cost $2 a year.

Corona's first high school is shown here under construction by local architect and builder Leo Kroonen Sr. "Corona is proud of such an edifice which is a monument to posterity and a credit to the city," read the 1907 headline announcing the dedication for this classic revival-style structure. It opened to 65 students in September 1907.

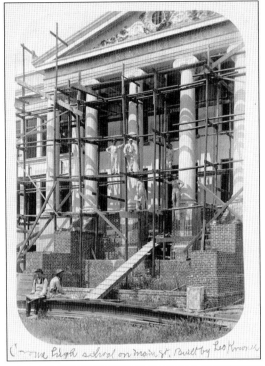

The Albert and Mabel Farmer home was located at 802 West Sixth Street. In this photograph from 1908, one-year-old Albert Edwin Farmer is sitting in the buggy with his father, Albert John Farmer, while mother Mabel Irene (Taber) Farmer stands near the horse. Albert Edwin Farmer was born in 1906 and died in 1986.

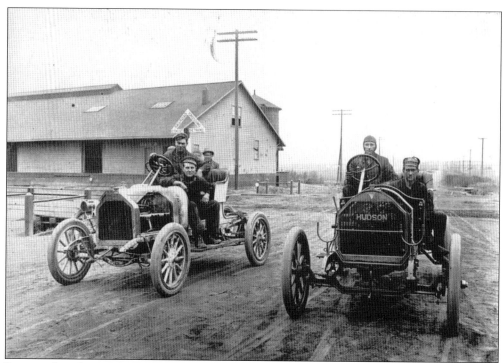

Prior to the advent of Corona's world famous road races, competitive speed contests between rival garages were held in town. It was Buick vs. Hudson in this Thanksgiving Day 1909 event. "Enthusiasm over the race is at white heat and an exciting event is predicted. Both machines have many supporters, and both drivers are confident of victory," read a pre-race *Corona Independent* article. The Buick was the victor.

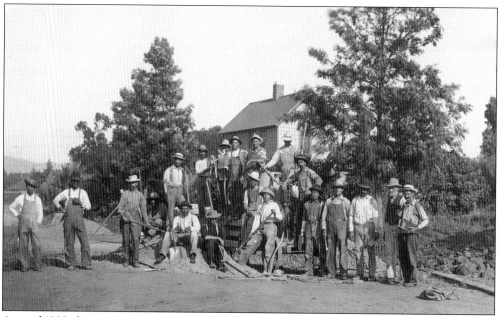

Around 1909, this construction crew repaired West Sixth Street near Crawford. This was reportedly the first improvement made to Sixth Street.

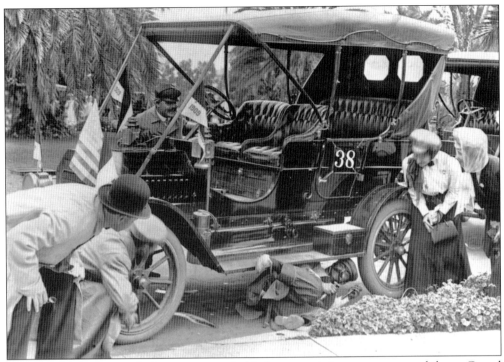

These people appear to be having a grand old time examining a new automobile on Grand Boulevard in 1909. Note the American flag, the 1909 banner, and the number 38. The women's hats and scarves protected them from dust and wind when traveling in a motorcar.

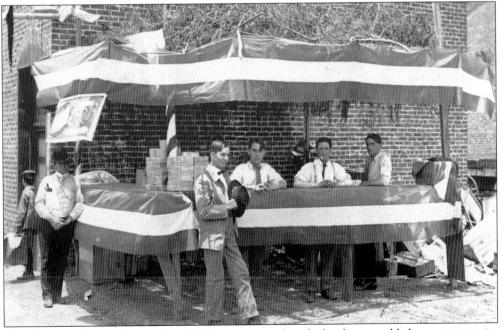

This photograph was taken on July 4, 1909, suggesting that the kiosk is most likely at a community Fourth of July celebration. Pictured, from left to right, are Judge Croker, George Drinkwater, Lynn Brooks, Elmo Veach, and Neil Livingston.

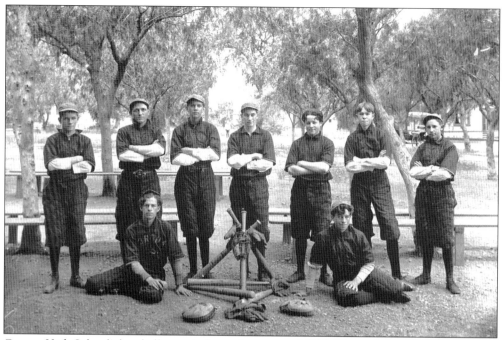

Corona High School's baseball team is shown here around 1910. The quilted pants protected the players from being injured while sliding.

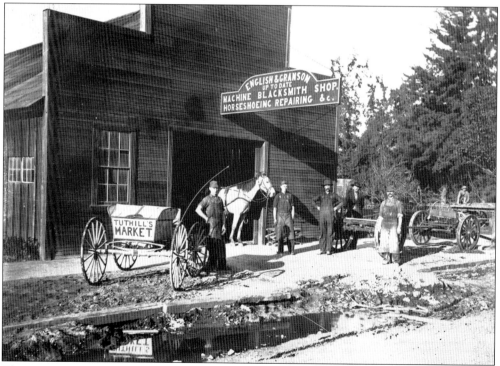

This 1910 photograph shows the English & Granson Machine Blacksmith Shop in Corona along with Tuthill's Market delivery wagon. Horseshoeing and wagon wheel repairs were advertised on the sign.

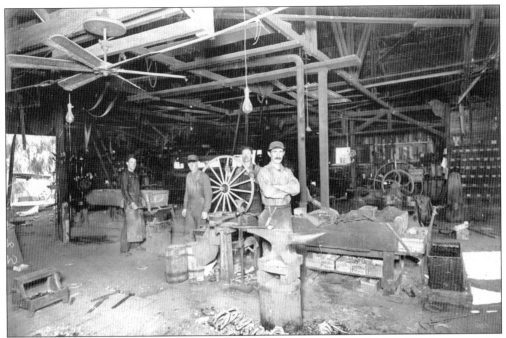

A working Corona blacksmith and wheel repair shop is shown around 1910. The four men with soiled clothing and smudged faces are surrounded by horseshoes and other equipment. One "smithy" holds up a just-repaired wagon wheel.

Mrs. E. A. Ashcroft stands in front of her home at 704 Joy Street around 1910. The fence is made of wood and chicken wire.

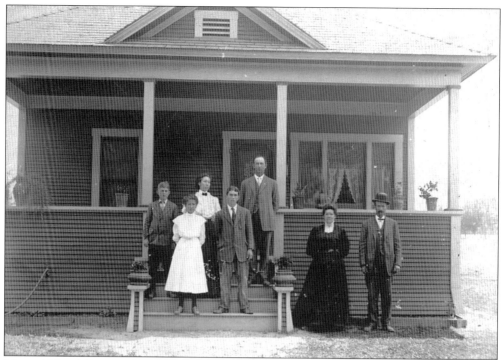

Mr. and Mrs. Allensworth are seen standing on the right at their house on East Olive in 1910. Their daughter Jewel, wearing the white dress, taught school in Corona for over 40 years. Her married name was Hutchinson and her husband served as Corona's assistant postmaster. The lace curtains and potted plants give the home an inviting appearance.

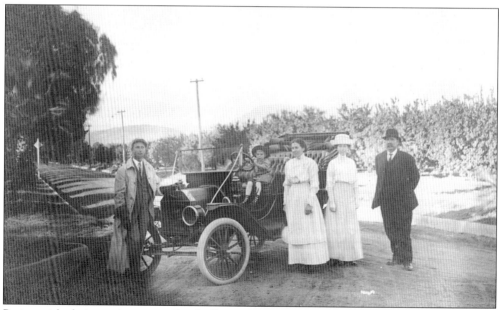

Posing with their touring car in South Corona in 1910 are, from left to right, S.J. Bowen, the young daughter of Mrs. Thacker, Mrs. Thacker, Mrs. Bowen, and George Thacker.

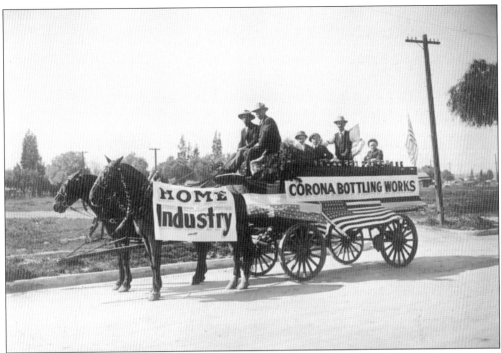

This wagon advertises the Corona Bottling Works, a carbonated beverage business that operated for many years at 408 West Sixth Street. Around 1910, when this photograph was taken, many drug stores bottled and sold their own brand of soda pop.

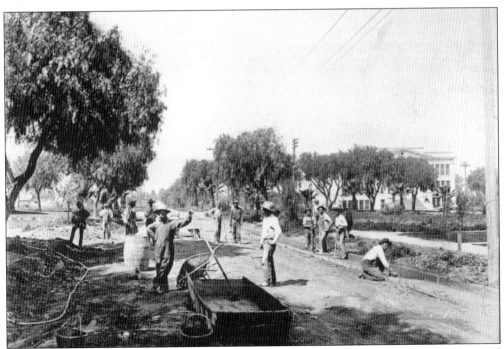

Employees of Enos-Bruckman-Kroonen Contractors install curb and gutter near East Olive and Main Streets c. 1911. Corona's first high school can be seen in the distance on the right.

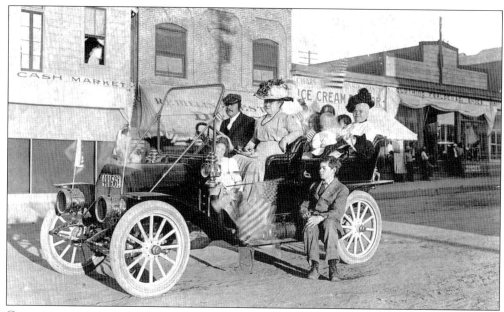

Coronans in a touring car, seen here around 1910, are Mr. and Mrs. Fred Baird (seated in front), Mrs. C. A. Peeler and grandchildren (seated in back), and Max Baird on the running board. The awning of the R. F. Billings Drugstore at 603 Main Street can be seen directly behind the vehicle. Next is an ice cream parlor and then F. S. Alden's Gent's Furnishings.

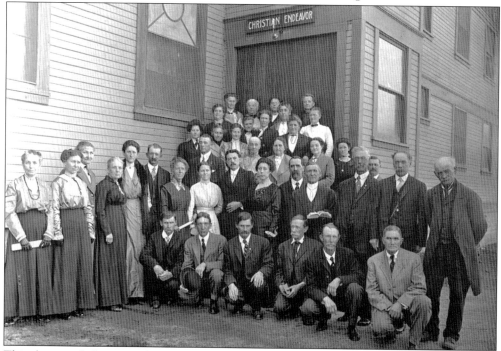

This photograph shows members of the Church of Christ, including Preacher Stivers, around 1911. "Christian Endeavor" is inscribed above the door of the church, which stood at the southwest corner of Ninth and Main Streets. The edifice was constructed in 1893 and was also referred to as the First Christian Church.

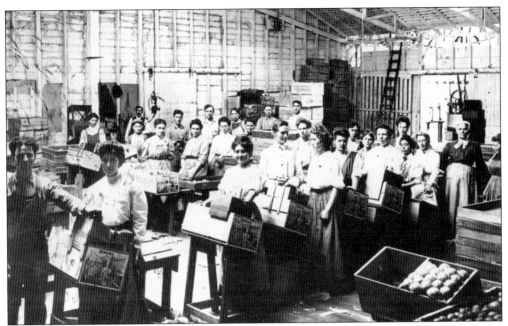

The interior of the Corona Lemon Company Packing House is seen here with 27 workers, mostly women. Men can be seen in the background; they usually did the heavy lifting. This image was taken around 1910 when women packers were paid $2.50 for eight hours of work. The Corona Lemon Packing House later became the Corona Foothill Lemon Company.

This house on East Grand Boulevard, photographed in the early 1900s, was the home of Judge John Main from 1894 to 1902. William H. Sargent lived here from 1902 to early 1920. Fire destroyed the top floor later that year. The upper story was removed by the next owner, a building contractor, and further renovations took place over the years. The house now has three addresses: 608, 610, and 612 South Grand Boulevard.

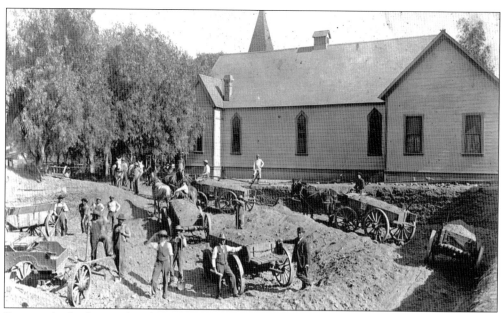

Seen in the background is the original 1887 First Congregational Church, the first church in town. Church members are seen in 1911 preparing the foundation for the new church building at the southeast corner of Eighth and Ramona Streets. The new building, which still stands today, cost $35,000 to build and was dedicated on October 5, 1911. The original church was relocated to East Sixth Street. It still stands in 2005, though it is no longer a church.

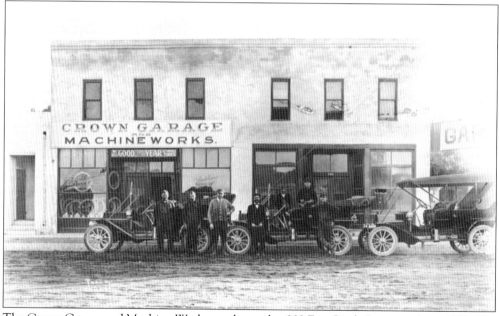

The Crown Garage and Machine Works was located at 202 East Sixth Street in about 1912. The business was owned by Fred M. Baird and William H. Peeler. "We sell Goodyear Tires" is clearly seen beyond the Studebaker automobiles at the curb.

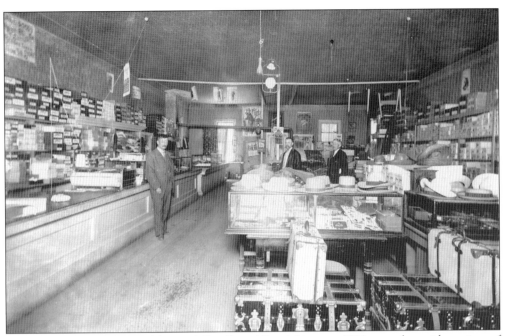

The interior of Frank W. Alden and Co. Gents' Furnishings, *c.* 1912, reveals a wide variety of items for sale for the discriminating gentleman. In a 1903 advertisement, shoes for men and women were sold for $1.75 to $3.50 a pair.

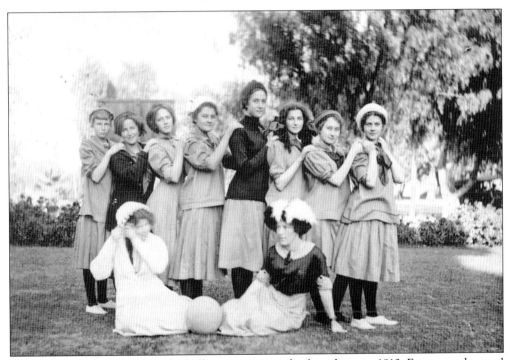

Corona High School's girls basketball team poses on the front lawn in 1912. Future teacher and Corona Junior High School principal Letha Raney is fourth from the left. Raney Intermediate School is named for her.

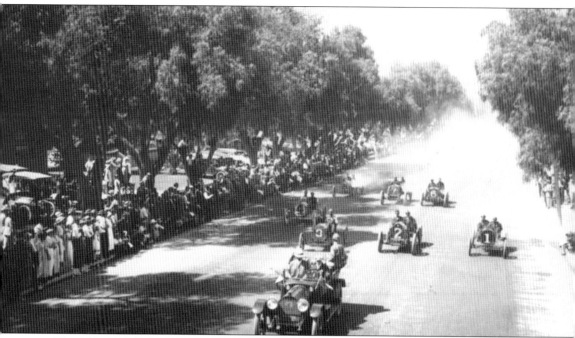

This photograph was taken from the pedestrian viaduct at South Main and Grand Boulevard on September 9, 1913. It shows the pace car and eight racers on the Grand Boulevard racetrack in Corona. Of the 12 racecars that started, only three finished the race. That isn't dust in the photograph but car exhaust due to castor oil being added to the gasoline. The cars and drivers were No. 1, Mercer, Oldfield; No. 2, Stutz, Margone; No. 3 National, Jeanette; No. 4 Fiat, Hill; No. 5 Mercer, De Palma; No. 6 Mercer, Wishart; and No. 7 Fiat, Verbeck.

Erected in 1914, this is the second building at the first Lincoln School campus on Ninth Street between Victoria and Howard Streets. It was once a U-shaped structure containing the principal's office, the nurse's room, the teacher's room, library, and classrooms. Lincoln School moved to its new Fullerton campus in 1951, and from 1951 to 1969 (when the district's offices moved to Buena Vista Avenue), the site served as the Corona School District's headquarters. Victoria Park is now located here, and the east wing of the original building is still in use.

This ticket is from Corona's first road race held on September 9, 1913. Since the public was wild about speed, Corona's leaders felt that holding an automobile race on Grand Boulevard was a way to bring attention to the town of nearly 4,000 residents. The $11,000 prize was second only to the purse offered in Indianapolis.

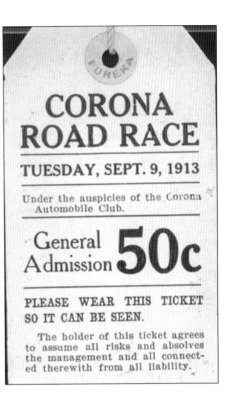

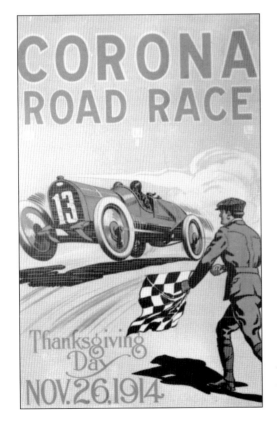

This is the official poster of the 1914 Corona Road Race held on Thanksgiving Day, November 26, 1914.

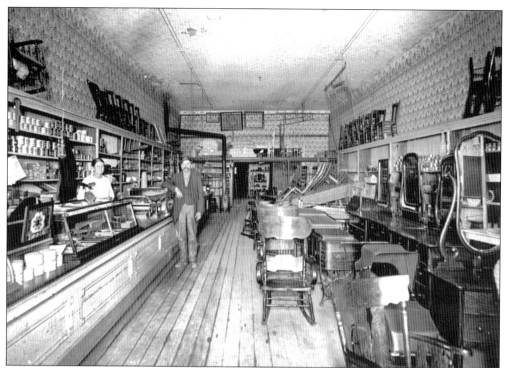

Among the merchandise for sale at Otto's Groceries in 1914 were picture frames, chairs, miscellaneous furniture, canned and bottled goods, a foot treadle sewing machine, a rocking chair, and a baby buggy. The store occupied the northwest corner of Main and Seventh Streets.

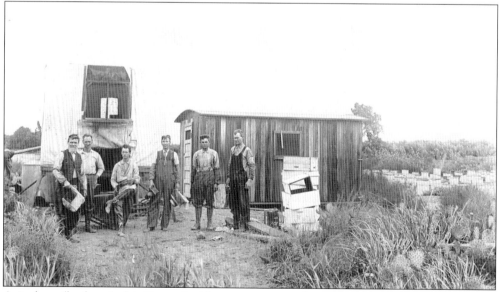

Apiculture (beekeeping) is Corona's oldest continuous industry, beginning in 1872 in the area of Temescal Canyon. Bees were necessary for pollinating agricultural crops, particularly in the citrus industry. In this *c.* 1914 photograph, well-equipped men are gathering honey in an open field. Beekeeper hats, long-sleeved clothing for arm protection, white hive boxes, and a storage shed were all necessary equipment.

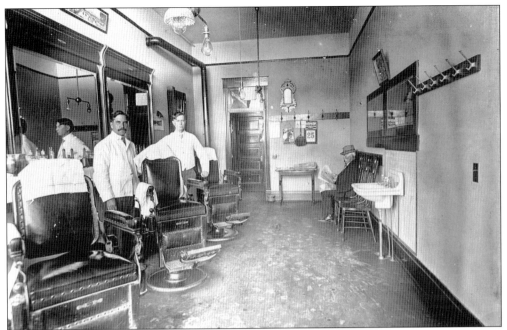

The Humble Barber Shop, owned by Bert Humble, is seen here around 1914. It is believed to have been located in the opera house building, which was also known as the Southern Hotel. The long picture hanging above the second barber chair shows the lineup of race cars for the September 9, 1913 Corona Road Race. A calendar is seen along the far wall, and a spittoon (or cuspidor) is conveniently placed by the door.

The home of Vivian and William L. Peeler was located at 812 Main Street. Here the Peeler family is standing beside an EMF car. Mr. Peeler had a bicycle shop and an automobile dealership as well as the Mission Garage. Peeler was instrumental in organizing the 1916 Road Race. On this same site, in 1933, and after some remodeling, Dr. Henry Herman opened the three-bed El Nido Maternity Home.

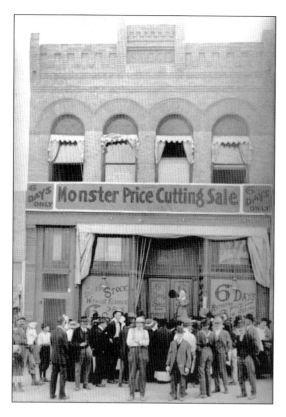

This building at 521 North Main Street was constructed about 1912. The downstairs was occupied by Emerson and Son, a dry goods store, and the upstairs was occupied by a chiropractor. The photograph was taken in 1914 just before the start of a "Monster Price Cutting Sale" at Emerson's.

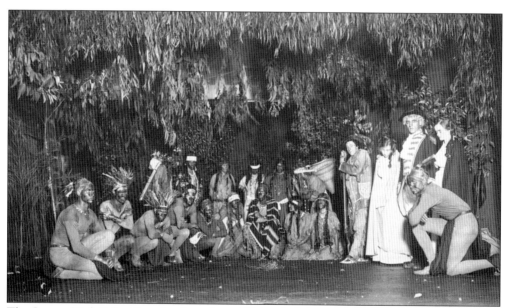

The Corona High School's senior class play in 1914 included scenes in which the students adapted incidents from several novels and wrote a play similar to *The Last of the Mohicans*. In addition to actors, participants included the Boys and Girls Glee Clubs and Native Americans from Sherman Indian High School who appeared as dancers in the play.

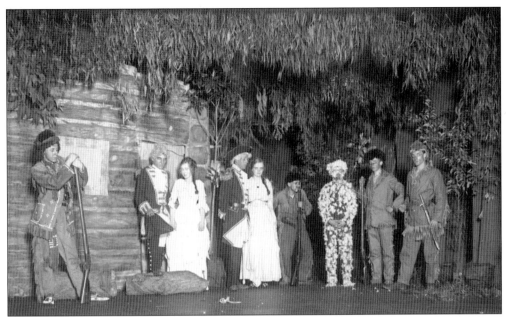

The man third from the right has been tarred and feathered in this scene from the 1914 high school play. The play was performed in the auditorium of Corona's first high school on South Main Street, now the site of Corona Fundamental Intermediate School.

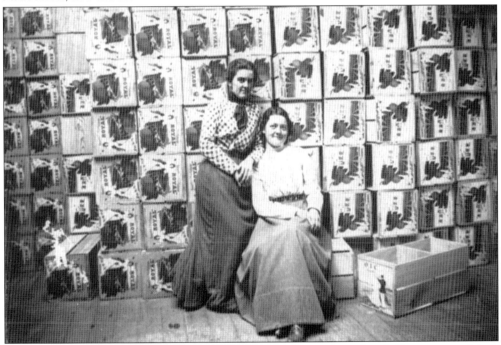

Two young women strike quite a pose in front of citrus boxes adorned with Corona citrus labels "Royal," "Queen Bee," and "O.I.C." Attaching brightly colored and attractively designed labels to the wooden crates helped with the national marketing of this locally grown fruit. Over 100 different Corona citrus labels were known to exist, and the Heritage Room of the Corona Public Library currently has 82 in their collection.

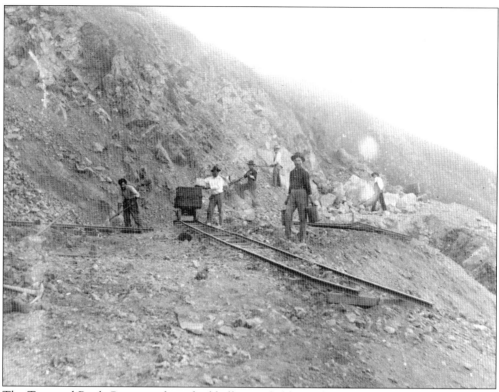

The Temescal Rock Company furnished ballast rock (the rocks upon which railroad tracks are laid) for building railroads. This 1915 image shows men working at the quarry face shoveling rocks into ore cars. The cars were then rolled down the tracks to the railroad. The company was later purchased by Blue Diamond and then by 3M.

Students and school staff pose on the steps of Corona's first high school in May 1915.

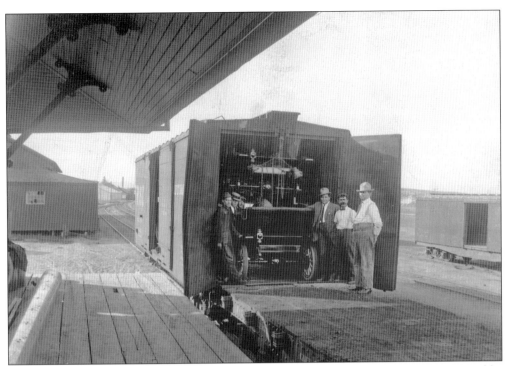

In the early 1900s automobiles were not driven to their dealership destinations but arrived by train. It took seven men to unload this Studebaker automobile from a railroad car at Corona's Santa Fe Depot.

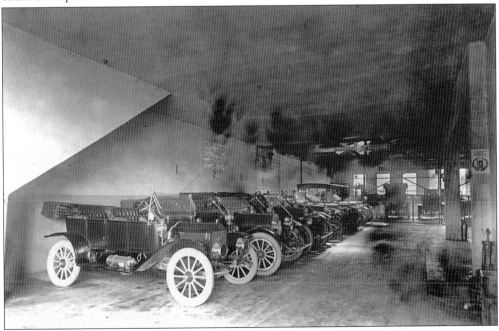

This Studebaker dealership showroom, c. 1915, was located at 215–216 Sixth Street. A poster offering Fireman's Fund Automobile Insurance through agent E. J. Genereaux is seen on the wall while a "Zerolene" sign touts its use for lubricating autos.

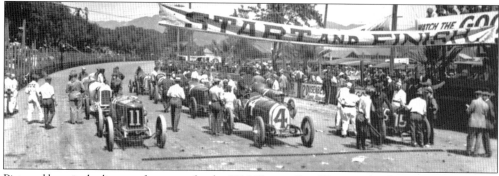

Pictured here is the lineup of racecars for the 1916 Corona Road Race as the drivers and mechanics complete last minute checks prior to the beginning of the race. Cars and drivers included No.1 Mercer, Thomas; No. 2 Sunbeam, Hughes; No. 4 Mercer, Pullen; No. 7 Peugeot; No. 8 Stutz, Cooper; No. 11 Delage, Oldfield; No.15 Gandy Special, Gandy.

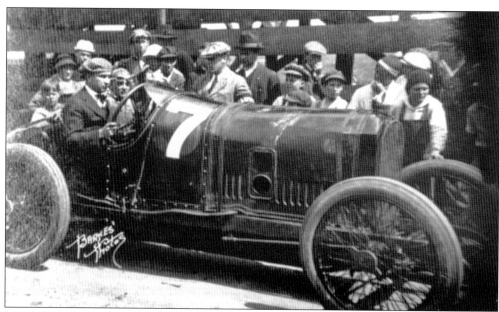

"Wild" Bob Burman and his mechanic pose in his No. 7 Peugeot racecar prior to the start of the 1916 Corona Road Race. William F. Nolen reported in *Barney Oldfield: The Life and Times of America's Legendary Speed King* that, before the race, "Bob's wife had pleaded with him not to compete at the big paved circle. She had a vivid dream where a blowout sent his car out of control. This is precisely what happened on lap 96. The hard driving veteran met his end at speed."

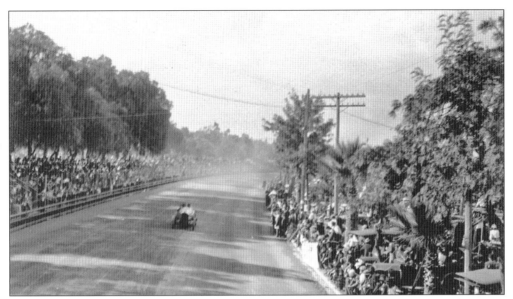

This image is from the road race held on Corona's circular Grand Boulevard on April 8, 1916. Thousands of spectators are seen in the grandstands and in the infield. The racecar and driver are not identified.

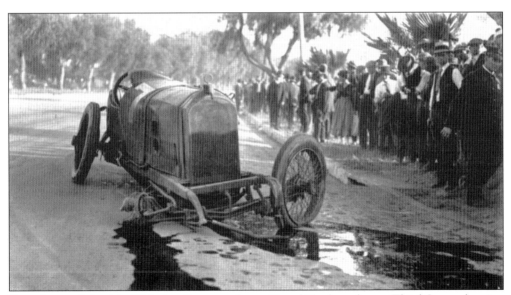

Tragedy struck in this 1916 view from northeast Grand Boulevard near Third Street showing the wreck of Bob Burman's Peugeot No. 7 after a tire blew out when Burman was going about 100 miles per hour. Burman died at Riverside Community Hospital. Mechanic Eric Shrader and special officer Will Speer of Corona were also killed as a result of the accident. Corona's claim to fame, the road races where world records were broken, came to an end.

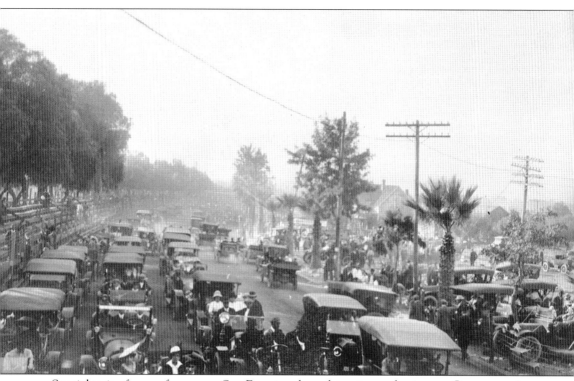

Special trains from as far away as San Francisco brought racing enthusiasts to Corona to witness the competition along the circular speedway. Thousands of motorists arrived early and spent the wee hours of race day huddled near campfires on roads leading to Corona's course. This is what Grand Boulevard looked like at the conclusion of the races. The number of automobiles and pedestrians along Grand Boulevard reflects high attendance at each of the three world-class road races. Attendance is said to have approached the 100,000 mark. The year this photograph was taken is unknown but is undoubtedly typical of traffic at the end of the day.

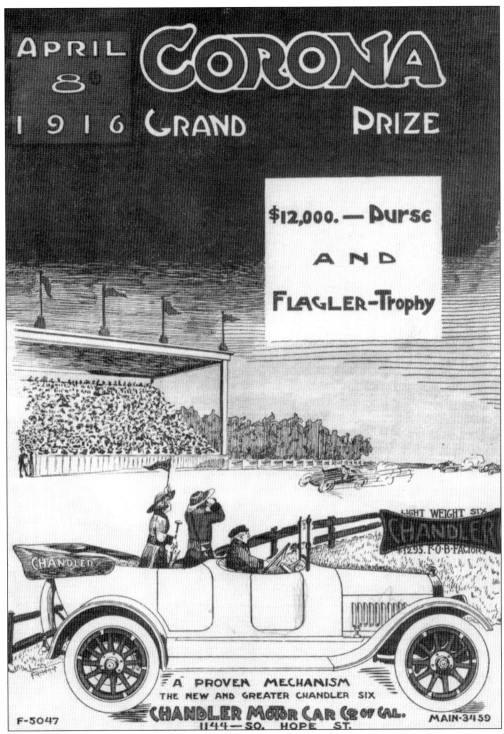

This is an official 1916 Corona Road Race poster. (Courtesy of Corona Heritage Museum.)

PBS television celebrity Huell Howser is seen here interviewing the author near the intersection of South Washburn and Grand Boulevard, where the start and finish line of the Corona Road Races was located. On March 23, 2002, Howser and his crew filmed an episode for the *California's Gold* PBS series the same day the Corona Historic Preservation Society dedicated an historic marker commemorating the races. (Courtesy of the author.)

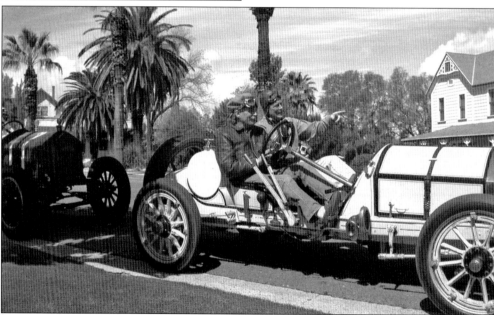

Huell Howser, wearing a leather helmet and goggles, rides along Grand Boulevard in a 1913 Mercer Raceabout with a 1916 National following behind. A reenactment of the race route with two vintage road racers took place along what was known during the Corona Road Races of 1913, 1914, and 1916 as the Corona Speedway. (Courtesy of Eugene Montanez.)

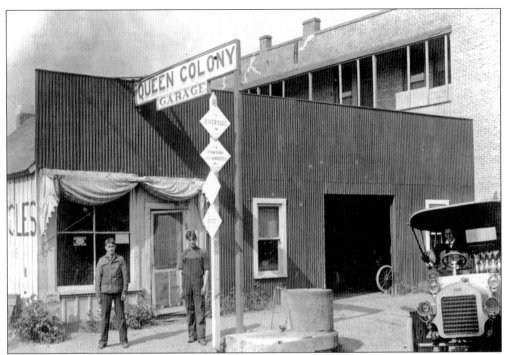

The Queen Colony Garage was located on the north side of Sixth Street between Washburn and Belle. Taken around 1916, this photograph shows Frank Raney standing next to the post showing directional signs to Riverside, Pomona, and Los Angeles. Frank Raney is the brother of Letha Raney, a prominent Corona educator. The garage specialized in the repair of both automobiles and bicycles.

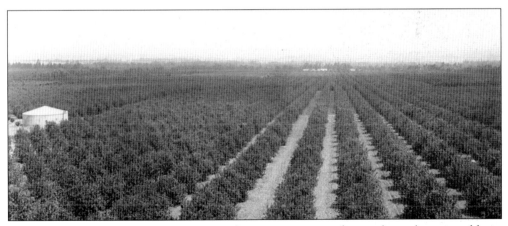

Corona was at one time a vast panorama of citrus groves extending as far as the eye could see. This eight-year-old Eureka lemon grove, owned by the Jameson Fruit Company, was photographed on May 18, 1917. It was located on Lemon Street, now called Chase Drive. Eureka lemons, which thrive in the Southern California sun, are known for their excellent flavor and abundant juice and are almost seedless.

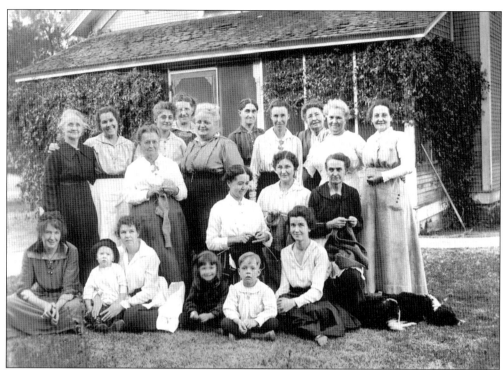

The Corona Carnation Crochet Club met at the homes of its members from 1918 to 1920. They crocheted and knitted woolen items and then donated them to the Red Cross. This photograph was taken at the home of Cornelia Garret at Fifth and Crawford Streets.

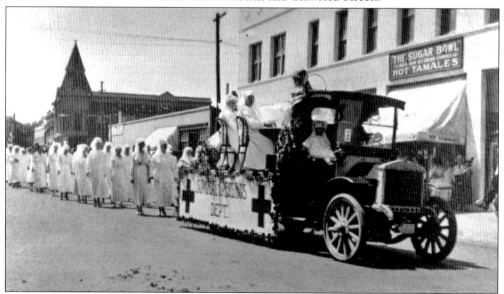

A World War I parade down Sixth Street includes a float from the Surgical Dressings Department of the Red Cross with nurses following behind. The Red Cross headquarters and shop were located on Main Street at that time. The float is passing the Sugar Bowl candy store located on Main Street, whose specialties included peanut brittle, creamy nougat, soft drinks, ice cream, and hot tamales.

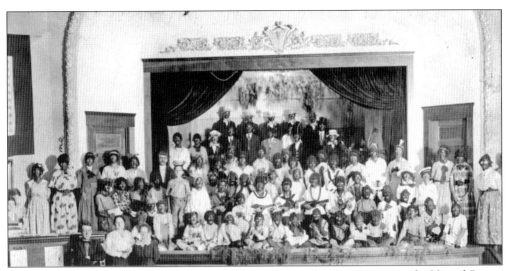

At one time, the minstrel show was a popular form of musical entertainment in the United States. The cast of this 1918 minstrel show consisted of Corona residents and was held in the auditorium of the first Corona High School on South Main Street. The school was built in 1907 and was once located where Corona Fundamental Intermediate School campus now stands.

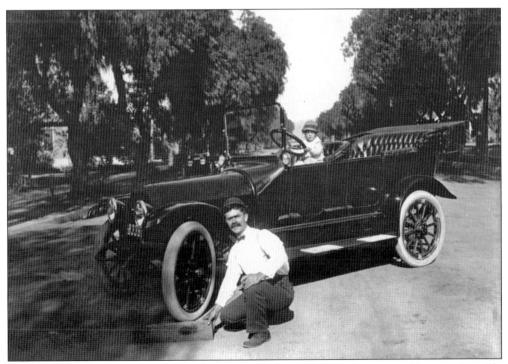

William H. Peeler changes a tire on his touring car c. 1919. His five-year-old son Calvin Ely sits in the driver seat. Peeler, a pioneer Corona auto dealer, was instrumental in promoting and financing the 1916 Corona Road Race. He also owned a bicycle shop on the ground floor below the Mission Apartments on East Sixth Street.

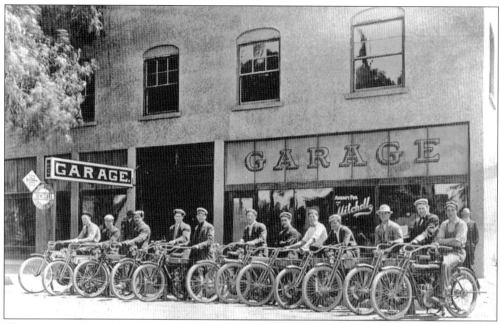

These motorcycle enthusiasts appear to be posing for promotional purposes in front of the Mission Garage, *c.* 1919. Mission Garage was an agent for Mitchell motorcycles at the time. There is a sign advertising Michelin tires as well. Located on East Sixth Street, the Mission Garage's second story was called Mission Apartments because rooms were available for rent.

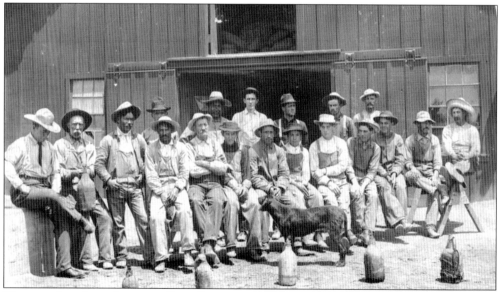

Citrus workers from American Fruit Growers sit in front of a barn during the 1920s. The jugs in the foreground, used for drinking water, were wrapped in canvas to keep the water cool. Mr. Summerfield is pictured on the left.

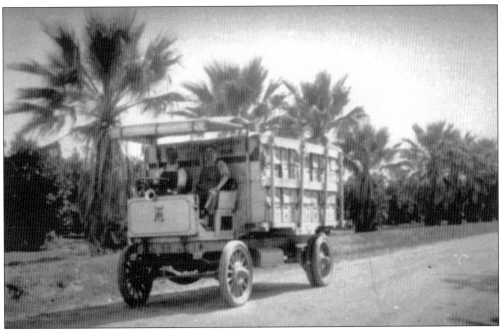

This scene, reminiscent of nearly any of the groves in town, shows a World War I era truck used in the citrus industry. It has hard rubber tires and is loaded with field boxes of fruit.

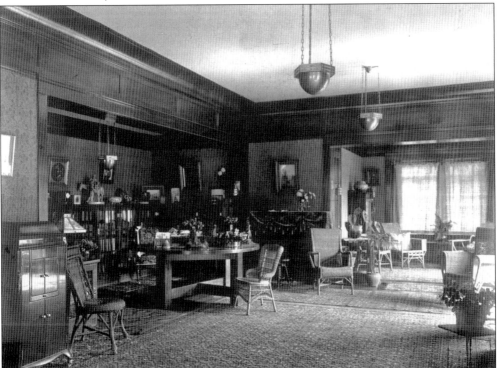

The living room of the Joy/Todd home, photographed around 1920, shows many of the furnishings that were acquired when family members made trips abroad. This home was built by George L. Joy and was later occupied by the Todd family.

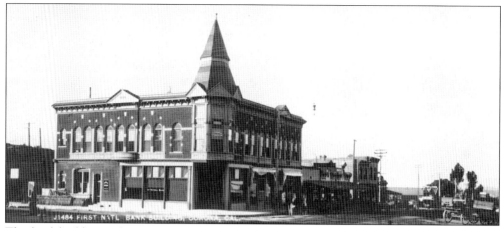

This brick building with its unique witch's hat cupola was completed in April 1888. It replaced the 16-by-24-foot wood building in which Citizens Bank began in August 1887. Citizens later merged with First National Bank and the structure was modernized in 1939. It occupied the northwest corner of Sixth and Main Street. Attorney H. F. Scoville and a market occupied other parts of the building when this photograph was taken.

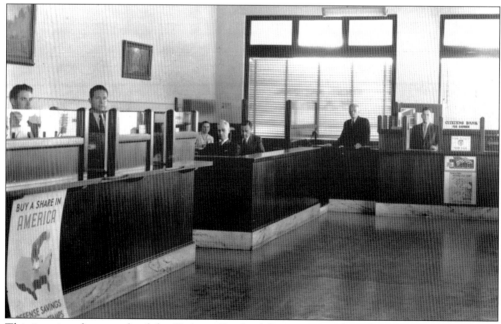

This interior photograph of the Citizens Bank of Corona was taken during World War II and shows two war bond posters displayed in front of the counter as well as seven members of the bank's staff. This building was located at the northwest corner of Sixth and Main Streets. Citizens Bank later merged with First National Bank.

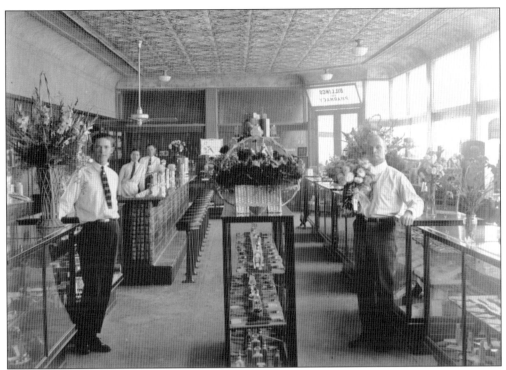

Shown here is the orderly interior of Billings Pharmacy sometime in the 1920s. Items of interest are the soda fountain on the left, the ornate ceiling, and the many bouquets of fresh flowers throughout. Rufus Sumner Billings is on the right and the man second from left may be Ralph Edmund Stanfield. The pharmacy's ownership passed from Rufus Billings to Ralph Stanfield and then to Virgil Cunning.

A palm-lined street in Corona, c. 1920, shows citrus groves on the right and the left. The view is probably from South Main Street.

This early 1920s image is of Derius and Emilie Alden, who arrived in Corona in 1904. Derius was known as "General" Alden, due to his recruiting efforts during the Civil War. Prior to their arrival in Corona, the couple worked in circuses and dubbed themselves the "smallest perfectly formed couple." He was four feet tall and she was three feet, ten inches. The Shetland pony and the miniature buggy were 50th anniversary gifts from the citizens of Corona. Derius was listed as a "glassblower" in a vintage telephone directory.

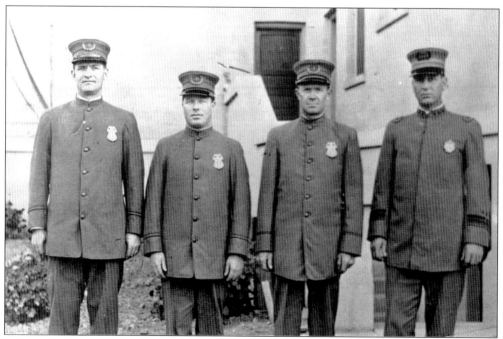

Four members of the Corona Police Department pose for a photograph around 1920. The police department's headquarters during that time was located in the basement of Corona's first city hall.

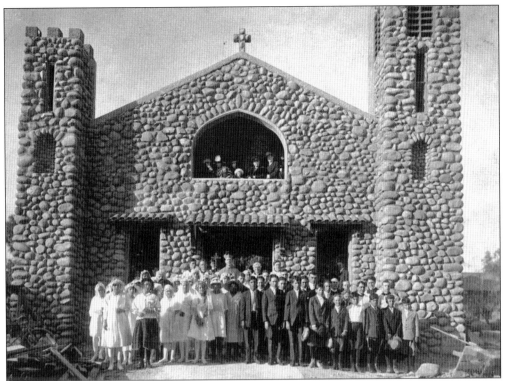

Corona's original St. Edward Catholic Church is shown here *c.* 1923 on the occasion of a confirmation. The Gothic revival-style church was dedicated in July 1919 by Monsignor Fitzgerald. Construction took three years using field stones collected by parishioners. Note the spectators in the unfinished second-story window. Located at 415 West Sixth Street, this unique structure was demolished in 1951 when the current church was dedicated.

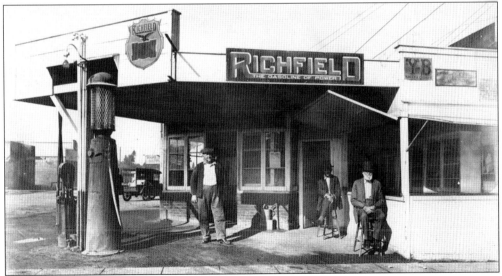

This *c.* 1925 photograph shows the Richfield Service Station located on the southeast side of Fourth and Main Streets. Three cigar signs are posted to the right of the Richfield sign. The watering can was in all likelihood used for filling radiators as cars of this era were prone to overheating.

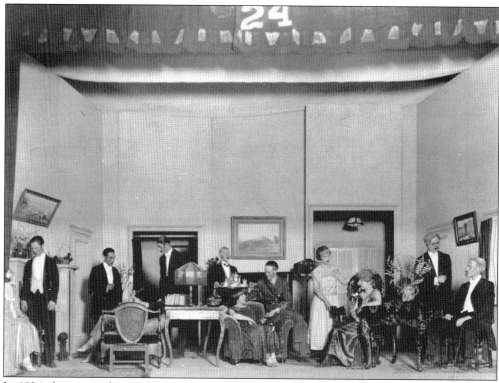

In 1924, the senior class performed the play *Green Stockings* at Corona's second high school on West Sixth Street. This auditorium is still in use today at the Corona Civic Center.

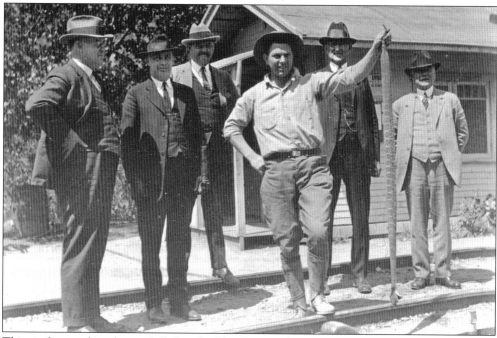

This six-foot rattlesnake was killed at the Blue Diamond Mine in 1925. The mine was located in Temescal Canyon in an area known for reptile infestations.

Theresa Maria Lemus was the queen at Corona's first Cinco de Mayo celebration in 1924. The parade route was around Grand Boulevard, and Lemus rode in a place of honor atop a new convertible. The celebration that year featured an abundance of food, folk dancing, songs, and speeches on the true meaning of Cinco de Mayo.

Jeweler Ethan Allen shares this tender moment with his son Merle in 1925.

Teenagers have fun while posing on the merry-go-round at Corona City Park, c. 1925. The park was established in 1913 and included a wading pool, a teeter-totter, a huge slide, swings, a baseball field, picnic areas, and a sand pile. A large cannon was a popular place to take photos until World War II when it was removed and melted down for the war effort.

Pictured here is Thomas Jefferson Grammar School shortly after it was built in 1927 at the southwest corner of Vicentia and Tenth Streets. Constructed of reinforced concrete, it had five classrooms and provided over 10,000 square feet of space. The school was built in just four months for $28,000, including $5,000 for the property. A south wing was added in 1931. It opened to 159 students in January 1928 and has served the youth of Corona for over 77 years.

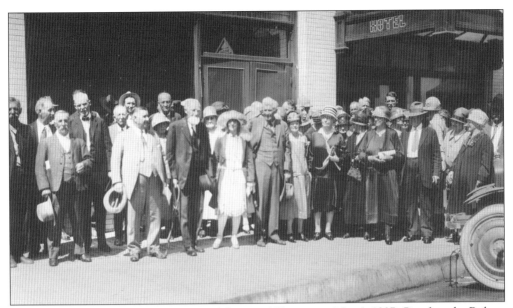

Founders' Day attendees pose in front of the Hotel Kinney on May 4, 1927. City founder Robert B. Taylor is seen front and center with white hair and wearing the lighter suit. Mr. Joy Jameson is in the back row on the right (the tall man just below the word "Hotel").

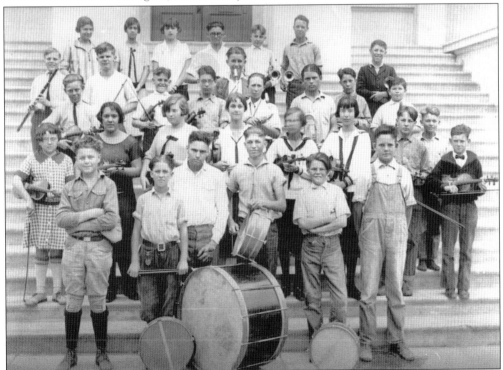

Members of the Corona Junior High School Band stand on the steps of the school on South Main Street, c. 1927. This stately neoclassical building served as a high school from 1907 to 1923 and as a junior high school from 1923 until 1937. It was torn down between 1939 and 1941 as a WPA project.

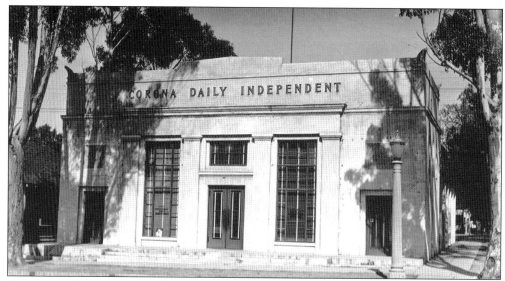

Here is the Corona Daily Independent Building as it appeared in 1928 shortly after it was constructed at the northeast corner of Main and Ninth Street. Used continuously as newspaper offices for over 70 years, it underwent several modifications over time and for many years the management conducted a separate commercial printing department.

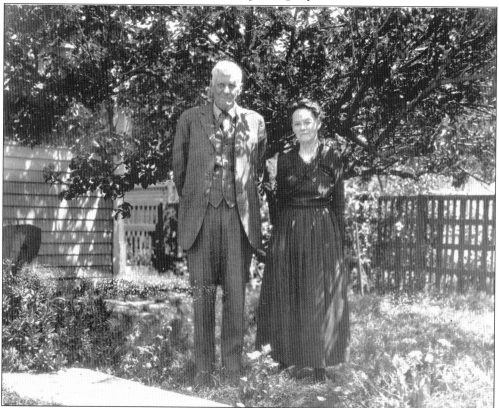

City founder Robert B. Taylor and his wife, Emma, relax in their backyard in 1928. R. B. could easily be identified in a crowd because of his height and his full head of white hair.

Señor M. Llamas rests in front of worker housing provided by the American Fruit Growers Association in 1929.

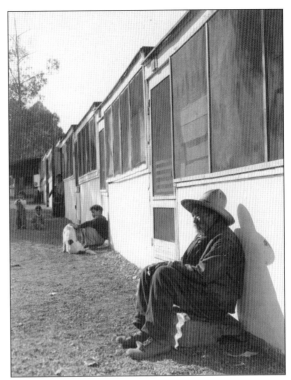

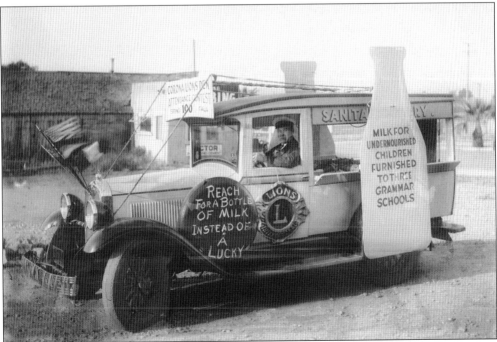

The Lions Club was a popular service organization during the late 1920s. Seen here is their emblem on a milk delivery truck from the Sanitary Dairy. According to the sign, milk was being delivered to three grammar schools to help feed undernourished children. Note the message on the spare tire cover advocating drinking milk rather than smoking.

Celebrities Al Jolson, Irving Berlin, and Laurel and Hardy attended the opening of the Corona Theater in 1929 at the northeast corner of Ramona and East Sixth Streets. Organ music once was played prior to the movie's start. Now known as the Landmark Building, it is the only pre-Depression theater still standing in Corona. Because of protests from local preservationists, its owners dropped plans to demolish this beautiful structure in 1991.

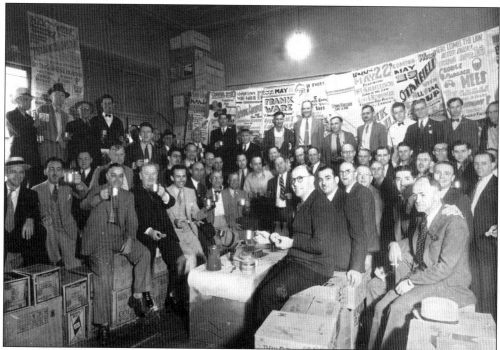

The Dunkers Club, shown here in this 1929 photograph, met in one of the storerooms of the Alpha Beta store located on the lower floor of the Odd Fellows Building on Main Street. Membership was open to men only and the club met every Wednesday to have doughnuts and drink coffee out of shiny metal mugs. Mr. Edwards from Alpha Beta started the group.

Sam Speer works in his hardware store on the south side of West Sixth between Merrill and Sheridan Streets, c. 1929. In addition to hardware, Sam's store also carried new and used furniture. According to an advertisement from that era, "Trade It" was the store's motto. Sam's father, Will Speer, was one of three persons killed as a result of the crash of Bob Burman's race car during the 1916 Corona Road Race.

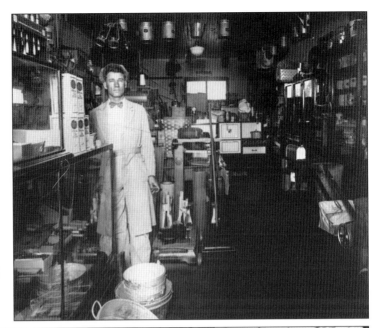

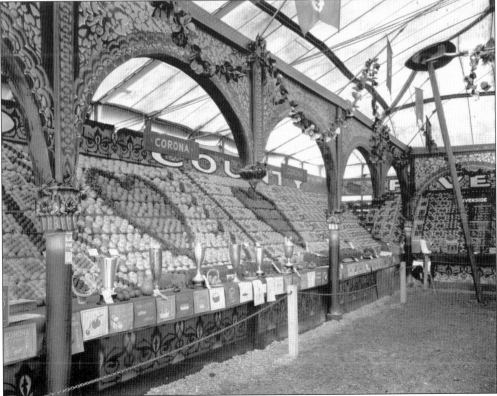

The very first Orange Show was staged in San Bernardino in 1889. Shown here is the Corona Chamber of Commerce exhibit at the National Orange Show in San Bernardino around 1929 along with citrus awards and posters made by Corona students. The pattern is formed by using a combination of lemons, oranges, grapefruit, and avocados.

Robert L. Willits came to Corona in 1912 from Indiana and built this craftsman bungalow in 1913 at 2412 Garretson Avenue. This photograph was taken in September 1930. Willits was president of the Corona Foothill Lemon Company and also served on the Corona City Council from 1914 to 1916. His wife, Shirley, was one of the first women to be admitted to Stanford University, Class of 1906, and was admired by many for her kindness to others.

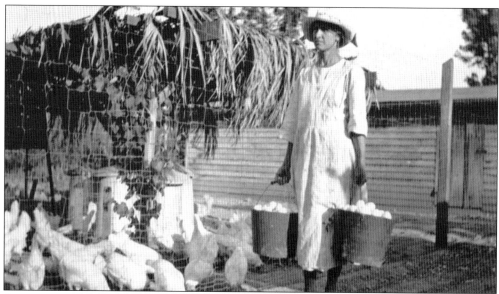

Corona was a small rural community during the early years and many families kept chickens and other farm animals. This c. 1930 photograph shows a woman performing the daily chore of collecting eggs. Two large buckets full of eggs indicate she must have many more chickens than appear in the photo.

Mr. Franklin and his violin class hold practice at Jefferson Grammar School sometime during the 1930s. Mr. Franklin once played with John Phillip Sousa's band before coming to Corona.

An unidentified woman sits on the bumper of a Buick on the left side of this photograph while Ruth Markowitz and 15-month-old Donald Markowitz pose next to a 1929 Chevy on the right. They are at the Jameson Southland ranch, which was planted by W. H. Jameson in 1894. This early ranch of about 150 acres was located between Buena Vista and Taylor Streets and Ontario and Lemon Streets (Chase Drive was initially named Lemon Street). A ranch house is in the background.

Leo Kroonen Sr., a local architect, designed the Mission Revival–style Washington Grammar School. Built by Frank Troop in 1911 at a cost of $23,700, the school included seventh- and eighth-grade students who were taught by the vice principal. Adult education classes were taught in the evenings making English classes available to many immigrants. This photograph was taken around 1930. The stately structure was demolished in 1950.

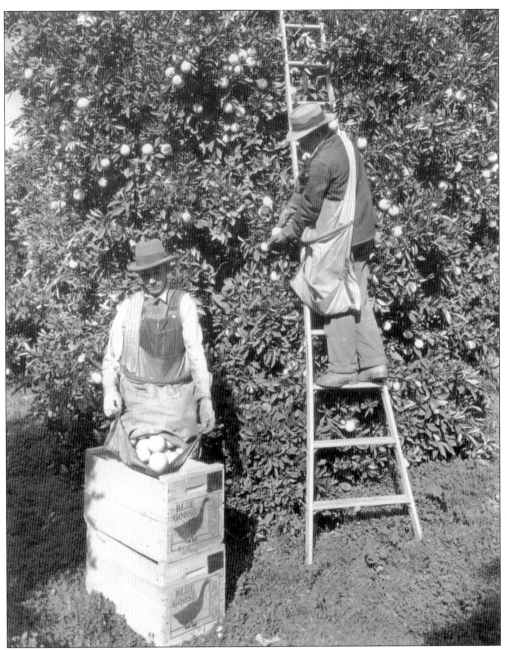

Two workers pick Washington navel oranges for the American Fruit Growers Association in a local grove in this photograph from January 1931. Citrus pickers were both men and women who were paid by the number of oranges picked, making money take on a new meaning. Pickers had to become very efficient and developed skills to work on three oranges at a time with one being clipped, one in the air, and one just having been placed into the shoulder bag. In 1887, Orlando A. Smith, owner of the Hotel Temescal, planted the first orange tree in South Riverside. By 1920 there were 11 packing houses in which fruit was washed, sorted, stored, and boxed to be shipped throughout the world. For 60 years, growing, packing, and processing citrus was Corona's main industry.

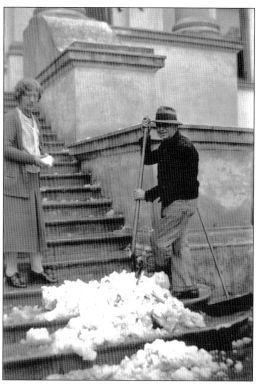

An unusual snowstorm on January 19, 1932 blanketed the Circle City in white. Teachers Anne Lawson and Jim Patton are seen here clearing snow off the steps of Corona Junior High School on South Main Street. It appears even the adults couldn't resist the temptation to make a snowball.

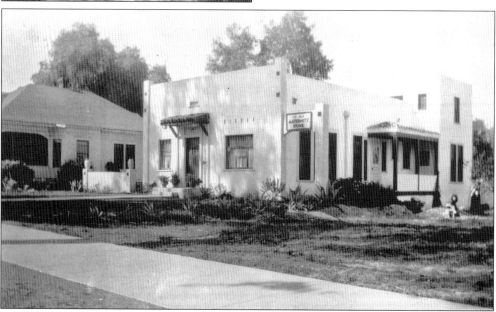

After delivering more than 200 babies in people's homes, Dr. Henry Herman established El Nido ("The Nest" in Spanish) Maternity Home at 812 South Main Street. This c. 1935 photograph depicts the structure after its first remodeling from a three-bed to a nine-bed facility. By 1941, after another expansion, the facility received licensure as Corona Hospital, where patients could expect to pay $19.71 per day. This hospital was the precursor to Corona Community Hospital, which evolved into today's Corona Regional Medical Center.

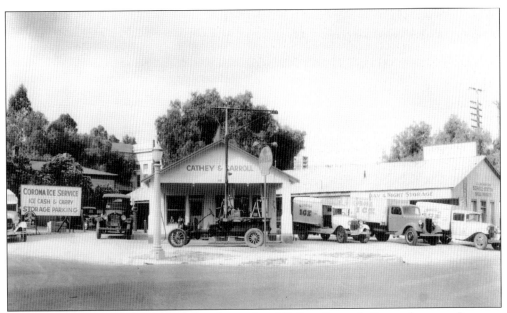

The Corona Ice Service Company was located at 118 East Seventh Street, between Ramona and Main Streets. This photograph shows a variety of vehicles and ice trucks arrayed around the buildings. The back of Corona's first city hall can be seen to the left of the lamppost. Two fuel pumps are visible under the overhang behind the Model T truck. L. L. Richardsen operated the service station offering Shell products.

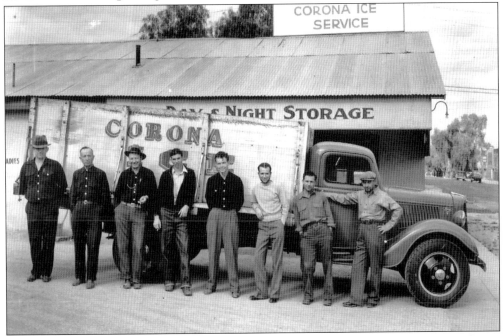

This Corona Ice Service Company photograph from 1934 shows the owners and six employees standing next to a company stake-bed Ford truck. Shown, from left to right, are Frank Carroll (co-owner), unidentified, George Cathey (co-owner), ? Humble, Bill Chambers, unidentified, unidentified, and unidentified. "Day and Night Storage" services are advertised on the building.

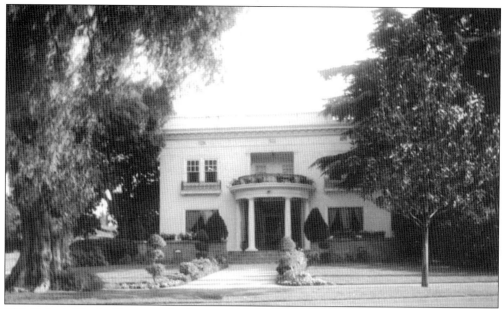

This Colonial Revival home was built around 1916 by Birdie and Fred Roberts, the manager of the local Wells Fargo Company offices who went on to become manager of the Queen Colony Fruit Exchange. This stately home still stands and sparkles in the sun at 1147 East Grand Boulevard. A six-by-eight-foot Tiffany-style stained-glass window in the back depicting a castle in the countryside is one the home's most unique appointments.

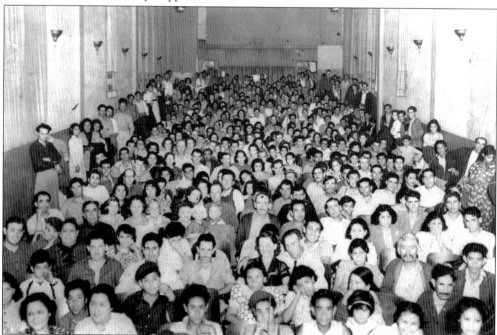

This c. 1935 image shows the audience at Teatro Chapultepec, also known as the Circle Theater. The theater, which showed Spanish language movies, was owned by J. Cruz and Sons and was located on Main between Fourth and Fifth Streets. Frances Martinez played the piano here for silent movies.

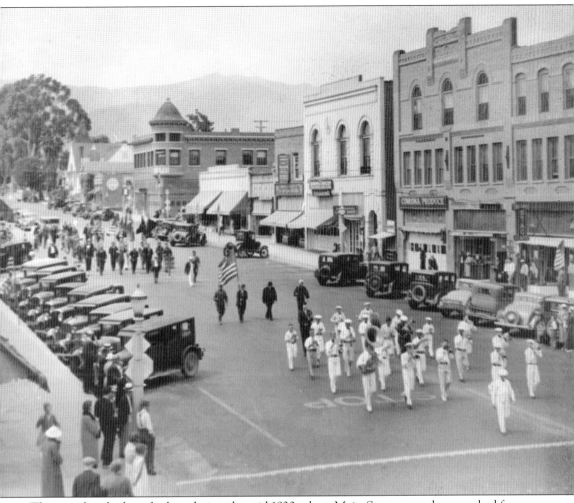

This parade, which took place during the mid-1930s along Main Street, was photographed from an elevated position at the northeast corner of Main and Sixth Street. The view extends from Sixth to Eighth Street with the west side of Main Street visible. The Southern Hotel, which also housed the opera house, is on the far right. The Lord Building with its distinctive cupola is slightly left of center and the First Baptist Church is just beyond that. Diagonal parking allowed men to sit on the fenders of their cars while their wives shopped.

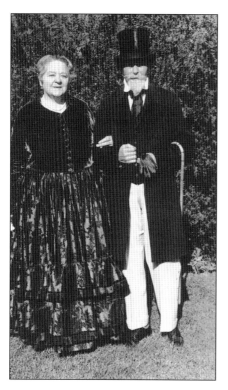

This photograph shows Mary Scully and an unidentified man during Corona's 50th anniversary celebration in May 1936. She is wearing an elegant "Spanish" outfit while the man portrays Baron Hickey, who nominated "Corona" when South Riverside needed a new name. Mary was born in 1866 in the Yorba Hacienda six miles west of town. She never married, was well liked, and was affectionately known as Aunt Mary to just about everyone.

Baby Manuel Enriquez, brother of Beatrice Ramirez, was photographed with a dog sometime in the 1930s at an unidentified home on Joy Street.

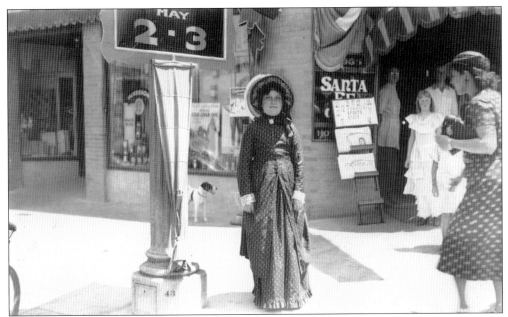

Ermagene Cunning is all gussied up in a costume to attend festivities commemorating Corona's 50th anniversary and golden jubilee, May 2–3, 1936. This celebration was a huge milestone for the Circle City, whose population had grown to nearly 8,000. Many gala events took place during the celebration including plays, concerts, dances, a rodeo, and a plaque dedication at City Park recognizing the city's founding fathers.

The newly constructed Manual Arts Building can be seen in the background of this scene taken around 1936 at Corona Junior High School. Preparation is being made by a truck and heavy equipment for constructing the foundation of an additional building near the corner of South Grand Boulevard and Main Street. Today the new building houses the library, the cafeteria, and classrooms.

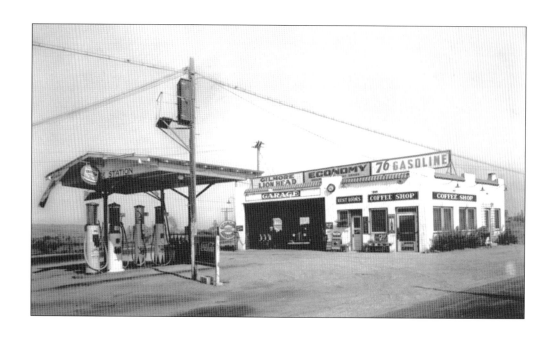

Five days of rain in February 1938 flooded this intersection of River Road and Main Street where the Y Service Station once stood at the northwest corner. The "Flood of 1938" caused great destruction throughout Southern California. Due to widespread flooding in Orange County, the Prado Dam was approved in June 1938 and its construction completed in 1941. (Bottom photograph courtesy of Corona Heritage Museum.)

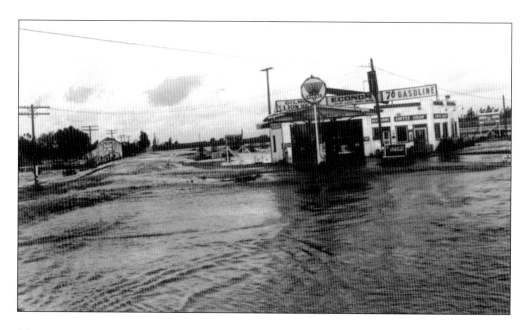

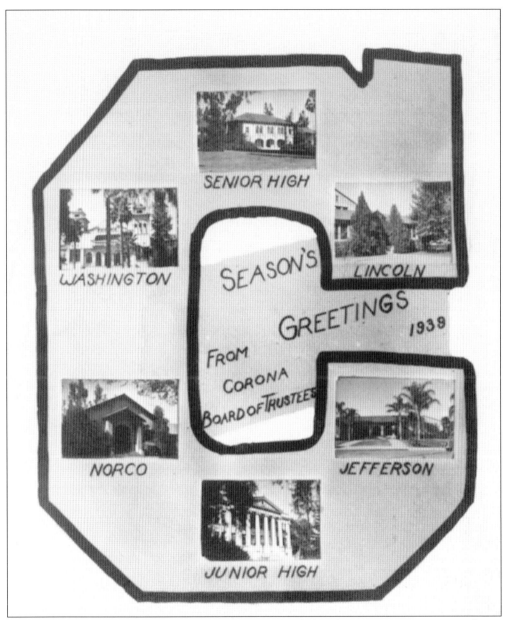

SENIOR HIGH

WASHINGTON

LINCOLN

SEASON'S
GREETINGS
1939
FROM
CORONA
BOARD OF TRUSTEES

NORCO

JEFFERSON

JUNIOR HIGH

This Christmas card was sent out by the Corona School Board in 1939. It incorporates photos of the district's six schools at the time: Corona Senior High, Corona Junior High, and the four grammar schools Lincoln, Washington, Jefferson, and Norco. (Courtesy of the author.)

Here is a happy crowd at the grand opening of the Foothill Ranch Company store, c. 1938. Citrus workers and their families were able to purchase food and clothing at the store. This building now serves as the museum at Corona's Heritage Park.

The Foothill Ranch Company store, offices, and gas station are seen here during the late 1930s. Food and clothing were available to purchase at the store. The building in the background currently houses the Corona Heritage Museum at Heritage Park at 510 Foothill Parkway. (Courtesy of Corona Heritage Museum.)

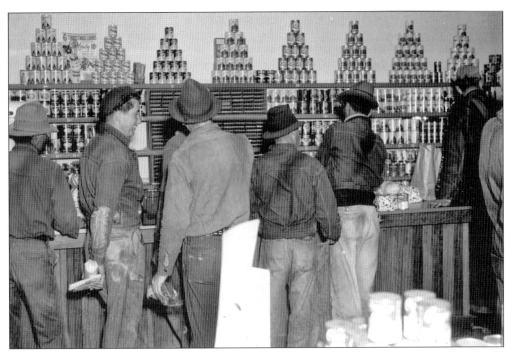

Corona Foothill Lemon Company employees shop in the ranch store. Other ranch stores existed in Corona as well. Peppertree Corner was the Jameson Ranch store and was located at the corner of Ontario and Fullerton Avenues. (Courtesy of Corona Heritage Museum.)

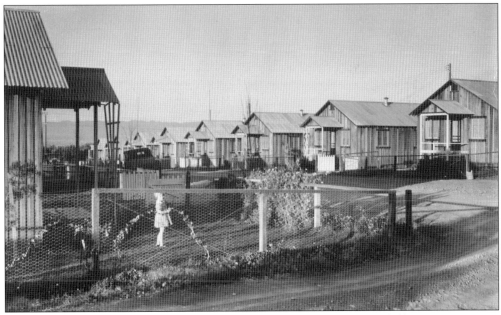

Shown here in the late 1930s is the Buena Vista "camp" of the Corona Foothill Lemon Company. Seasonal workers lived here during the picking season. The ranch was the single largest lemon ranch in all of California with over 2,000 acres, helping Corona to become known as "the lemon capital of the world." (Courtesy of Corona Heritage Museum.)

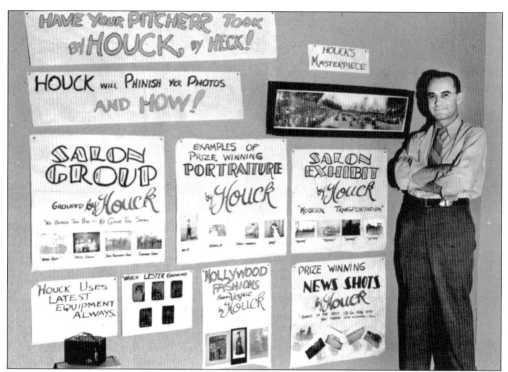

Photographer Lester Houck stands by a variety of advertising posters, c. 1938. His studio was located at 205 East Sixth Street and offered portraits, cameras, greeting cards, and a gift shop. Houck's photographs are found on many of Corona's vintage postcards. His masterpiece is seen here in the panorama image of the pre-race lineup of the 1916 Corona Road Race.

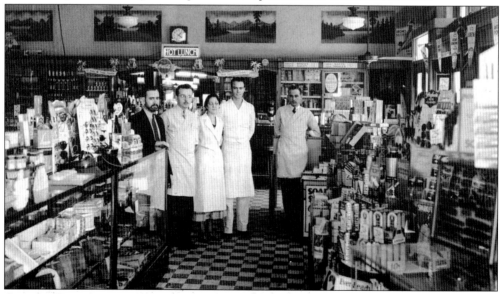

Cunning Drug Store, c. 1938, offered shakes and malts for 15¢ at the lunch counter in the background. Other items offered for sale included Bromo Seltzer, Perfecta sunglasses, Ever Ready shaving brush (in the foreground), Coca Cola "A Taste of Tropic Sunshine," and Wrigley's Pepsin Gum. Hairbrushes and women's handbags are found in the glass counter on the left.

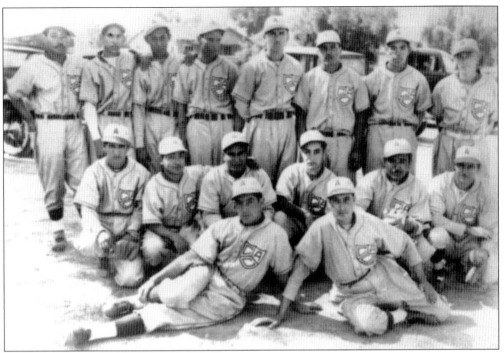

Sports have always occupied a prominent place in Corona's community activities. This c. 1939 photograph highlights a Corona Athletic Club baseball team.

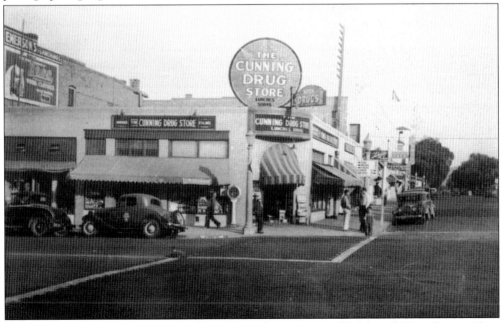

The Cunning Drug Store was located on the northeast corner of Sixth and Main Streets. Note the historic lamppost and the mileage sign above the awning in this c. 1938 photograph. The next building on Sixth Street is Hotel Kinney, and next to that the Corona Theater, now known as the Landmark Building. Mr. Stanfield was known to project silent movies onto the circular sign above the drugstore when he owned it.

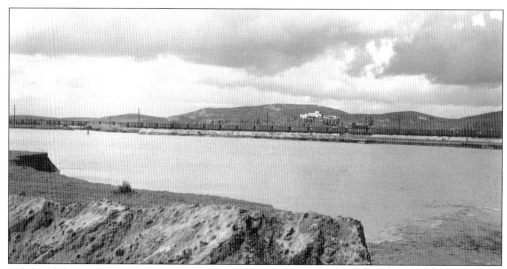

A lake of floodwater formed in this old gravel pit east of Corona as a result of the flood of 1938. The area seen here is north of Magnolia just west of Radio Road. The Parkridge Country Club can be seen on the hillside in the center of the photograph. The country club's golf course served as a precursor to the Cresta Verde Golf Course.

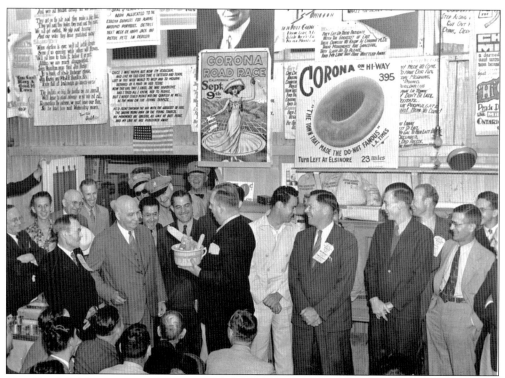

Gov. Frank F. Merriam visited Corona to view the damage done by the flood of 1938 and is seen here meeting with the Dunkers Club. Started by six businessmen in 1932, the club grew from 75 to 100 men by 1936. The group boasted it had "no elections, no rules, no ethics, no by-laws, no nuthin'." The fun-loving members simply quaffed their java and munched on doughnuts.

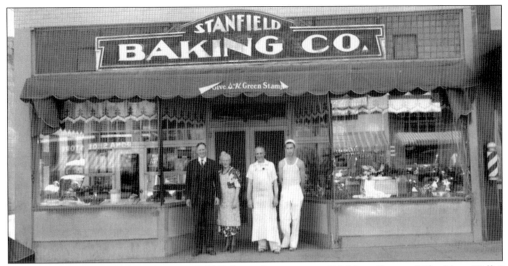

This 1939 photograph is of the Stanfield Baking Company at 613 Main Street. "The Taste Tells" was their advertising motto. A sign on the awning indicates S & H Green Stamps were given with purchases. The right door leads to The Corona Flower Shop, identified on the window on the right. The reflection on the left window indicates that Roma's Shoe Store was directly across the street.

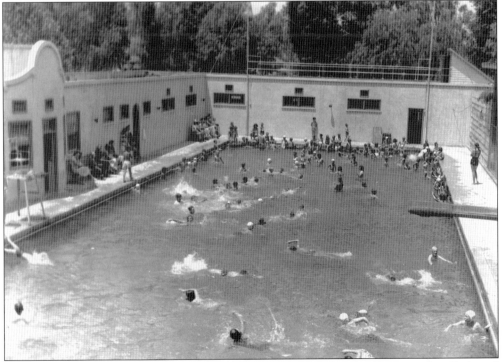

Corona's Municipal Plunge was built in 1925 by local builder G. C. Berner at City Park and served the community for nearly 40 years. In the 1930s, swimmers could wear their own suits or rent black wool bathing suits that were laundered through the door on the right. First the suits were washed, then soaked in "sheep dip" to disinfect them, and then air dried. This swimming pool complex was demolished in 1967.

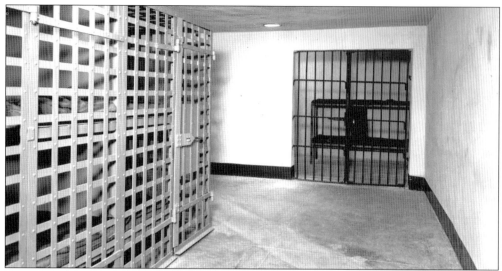

Corona's jail, located in the basement of the city's first city hall, was completed in 1913 just before the first Corona Road Race took place. Former Chief of Police Joe Greer once said, "The only thing it needed to look like a dungeon was to have some poor devil chained to the wall."

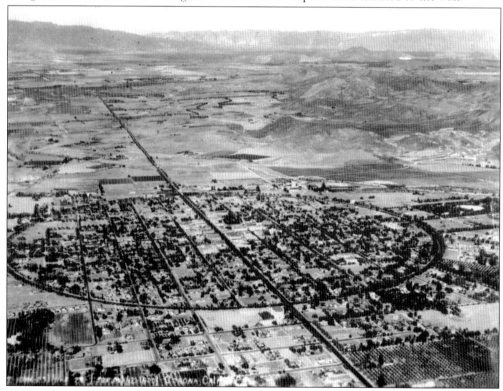

An aerial view of Corona looking north, c. 1939, shows its distinctive Grand Boulevard. At three miles around, it was—and is—the only street of its kind and scope in Southern California. If you look closely, Corona's first high school campus can be seen in the foreground. The Lemon Exchange Products Company (Sunkist) is in the background just beyond "the Circle" on the right.

Three

RECENT DECADES
1941

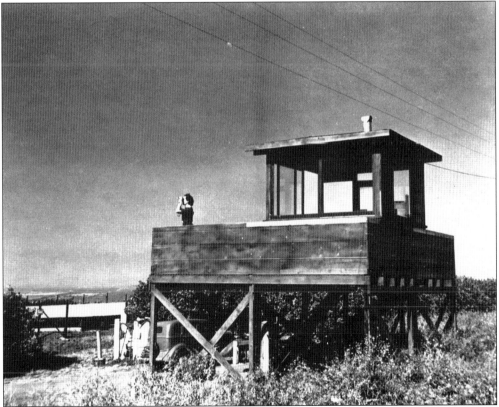

Typical of civil defense practices at the time, a woman atop a lookout tower located in South Corona during World War II searches the skies for Japanese aircraft. It was thought that Corona would be a good target or navigation aid for the Japanese because the Grand Boulevard circle was easily discernible from above.

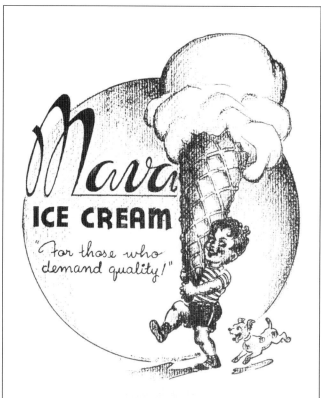

Mava Ice Cream, whose logo is shown here, was founded in 1930. The company was named by combining the first names of founders Mabel Berner and Ava Ridgeway. In 1934, Frank and Allie Belle Morrell bought out Frank's boss's four-year-old business. At their peak, they operated five retail outlets in Corona, Pomona, and Elsinore, featuring 20 flavors of ice creams and sherbets. (Courtesy of Heritage Park Museum.)

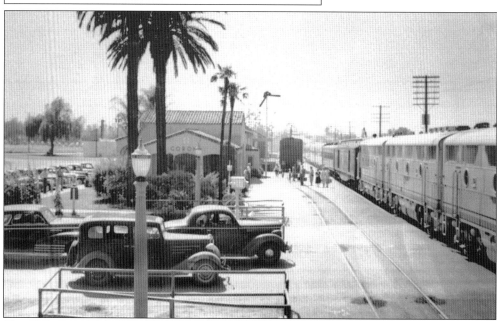

Shown c. 1941, Corona's second Santa Fe Depot was built in 1937 at a cost of $35,000 in Spanish Revival-style architecture to commemorate the 50th anniversary of Corona's founding. It served as the transportation hub of the city during World War II and until the automobile claimed its supremacy. Passenger service ended in 1968 and freight stops ended in the early 1980s.

HOT FUDGE SUNDAE
Made with 2 Dippers Ice Cream, Chocolate Fudge, Whipped Cream and Cherry

75c

''IT'S REALLY A TREAT''

BANANA SPECIAL 85c

Made with a whole ripe Banana, Chocolate, Strawberry, Vanilla Ice Cream, Chocolate, Pineapple, Marshmallow, Strawberry Topping, Whipped Cream, Nuts and Cherry

SUNDAES
Plain ———————————————————— 50c
With Whipped Cream and Nuts ———— 70c

Chocolate, Strawberry, Pineapple, Marshmallow, Butterscotch

ICE CREAM SODAS ———————————————————— 40c

Chocolate, Strawberry, Pineapple, Cherry, Lemon, Root Beer, Vanilla

MILK SHAKES, Double Rich and Double Thick ———— 50c

MALTED MILK, Double Rich and Double Thick ———— 55c

Shake or Malt made with real Ice Cream 10c Extra

Vanilla, Chocolate, Strawberry, Pineapple, Cherry Lemon, Root Beer, Butterscotch, Marshmallow.

Only our Highest Quality Ice Cream used in all Sundaes, Sodas and Banana Specials.

Carry Out Ice Cream

Pints ————————————35c

HAND PACK
Pints ————————————50c
Quarts ———————————98c

FOR YOUR FREEZER
Half Gallon ————————1.05
3 Gallons ————————6.30

Coca-Cola ——————15c & 30c
Fresh Lime Coke ——————20c
Fresh Lime Rickey ——————30c
Root Beer Float ——————35c
Sherbet Freeze ——————40c
Fresh Lime-Ade ——————30c
Ice Cream — Dish ——————30c
Root Beer Frost ——————45c
Chocolate Frost ——————45c
Root Beer ——————15c & 30c

— Dry Ice packing for small additional charge — 50c Minimum —

This 1941 menu is from a Mava Ice Cream Parlor, one of three parlors that existed in town, all on Sixth Street. In 1941 the Morrells opened a new factory and store on West Sixth Street and for many years sold their ice cream to other small retail outlets on a franchise-type basis. An advertisement in 1957 claimed, "We make the fastest disappearing ice cream in town." By the 1960s, the soda fountain business was waning but Mava's wholesale business was taking off. The largest account the Morrells acquired was the Del Taco drive-thru restaurants with more than 50 outlets by 1970. Allie Belle and Frank retired after 36 delicious years and were finally able to take the time off they'd missed from being tied to a successful business. Frank died about 11 years ago, Allie Belle in 2003. (Courtesy of Heritage Park Museum.)

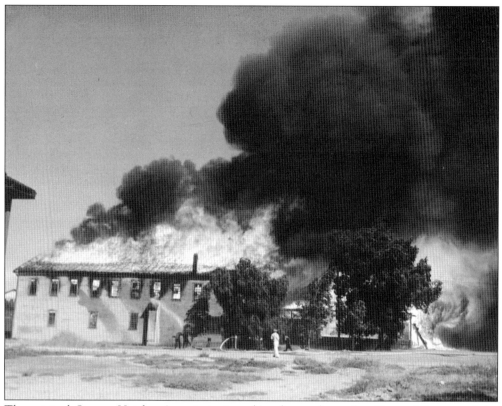

The original Orange Heights Association's packing house, located at Howard Street and the railroad tracks, was destroyed by fire on September 21, 1941. Here Corona firefighters direct water on the burning building.

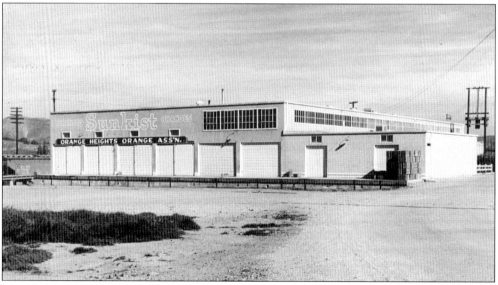

The Orange Heights Association's new packing house replaced the original after it was destroyed by fire on September 21, 1941. Purchased by Sunkist in 1958, it was the last of Corona's packing houses and closed in 1998.

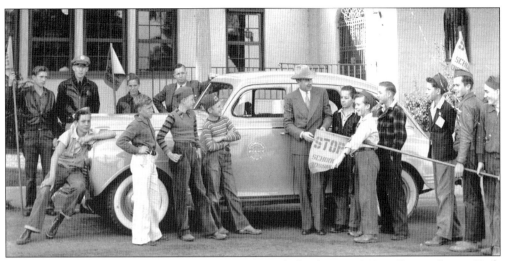

The Corona Police Department trains crossing guards for duty c. 1941 at Corona Junior High School west of Main Street on Grand Boulevard.

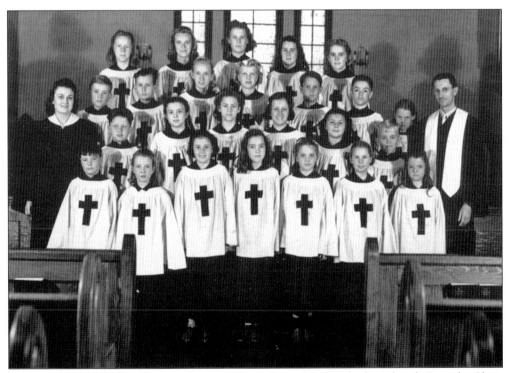

Taken in April 1941, this photograph shows 25 members of the Methodist Church Crusader Choir with director J. Lorin Farmer and assistant director Margaret Lee.

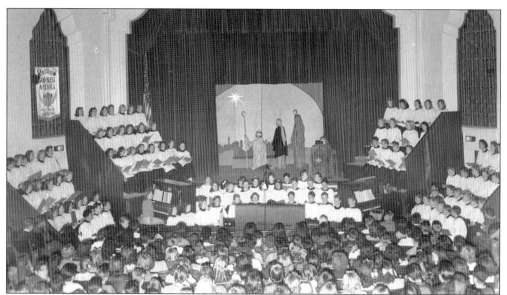

The Corona High School auditorium at 815 West Sixth Street provided a wonderful venue for a Christmas performance of the Corona Junior High School Choir in December 1941.

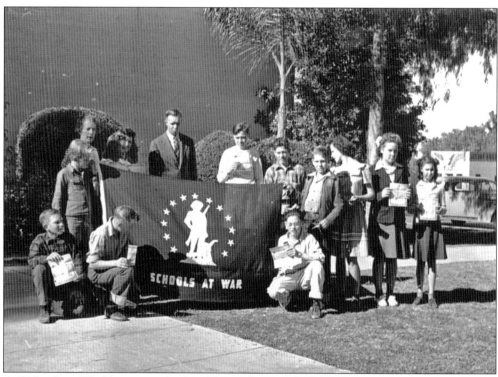

A "Schools at War" banner is displayed by students and adults at Corona Junior High School during the early 1940s. The "Schools at War" effort was a promotional program for students to purchase war bonds during World War II. The photograph was taken near the southwest corner of South Main and Grand Boulevard.

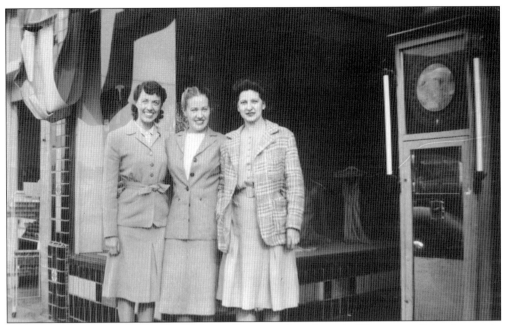

Teachers Eula Neary, Ann Teller, and Bess Downing from Lincoln Elementary School stand in front of a dress shop in downtown Corona in 1942.

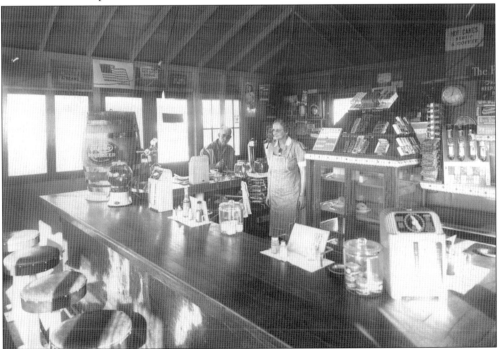

Owner Stella G. Hanna and a customer pose for a photograph inside the La Corona Circle Inn Restaurant at 8:03 a.m. sometime in 1942. Stools and the wooden counter are in the foreground while other items of interest are a keg of Menlo root beer, jukebox music selectors, window trays for carhop service, and cookie jars. Butterfinger, Big Hunk, Hershey's, Mr. Goodbar, Dentyne chewing gum, and Fritos are available for purchase.

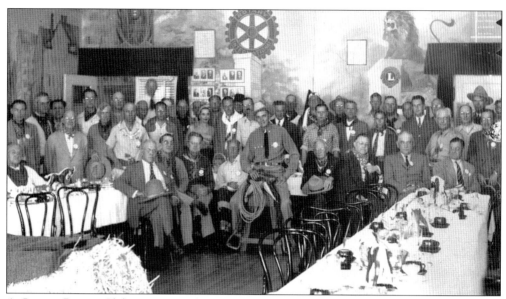

A Corona Rotary Club meeting with a western theme was held in the dining room of Hotel Kinney on June 27, 1945. Clarence Steves is the man sitting on the saddle. Mr. Joy Jameson is seen wearing the hat on the far right. Horse decorations adorn the tables while many Rotarians don bandanas.

In 1945, Soap Box Derby racers gather at the service station at the corner of West Sixth and Belle Street. These races were held on South Main Street and the route went from the first Corona high school building on South Main to the Santa Fe Depot at North Main Street.

This must have been an important community event for so many adults to gather at City Park sometime during the 1940s. The reason may have had to do with war bond issues, which were sold during World War II. The rear of Corona Municipal Plunge can be seen in the background.

Students lounge on the front lawn of the second Corona High School located at 815 West Sixth Street *c.* 1945. Many community activities have taken place on this beautiful grassy area over the years.

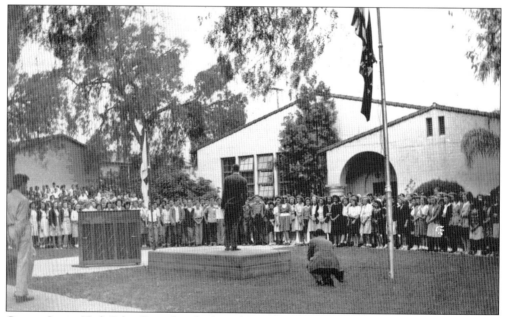

Corona Junior High School's student body and faculty celebrate Victory in Europe Day in 1945 at the east entrance of the school near southwest Grand Boulevard. This building is still in use today at Corona Fundamental Intermediate School and houses the library, cafeteria, and classrooms.

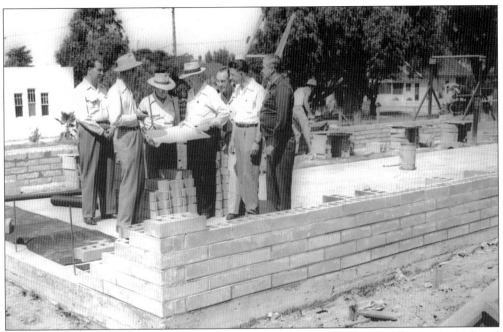

Photographed in 1947, members of the Lions Club study the plans for the Scout House at Ninth and Belle Streets.

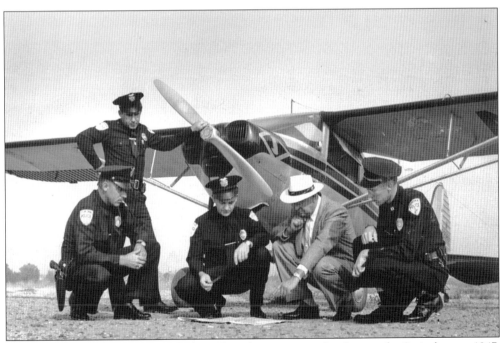

The Corona Police Department's Aero Squadron poses with a Luscombe 8 airplane c. 1947. Pictured, from left to right, are Officers Switzer, Compton, Farnham, Lowery, and Greer. The location, known as the Kuster Landing Field, was established in 1939. Joe Greer joined the police department in 1940 and served as chief of police from 1966 until his retirement in 1976.

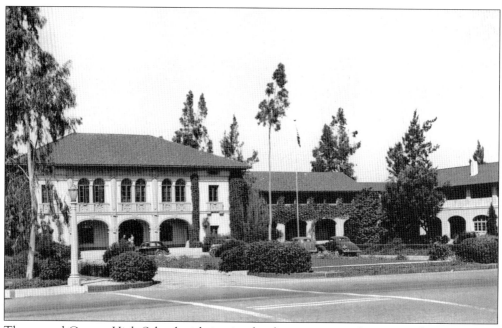

The second Corona High School with its circular driveway is seen here around 1947. Built in 1923 for $150,000, it served as a high school until 1961 when students moved to the new campus on West Tenth Street. The vintage buildings at this site served as Corona City Hall and Civic Center from 1962 to spring 2005.

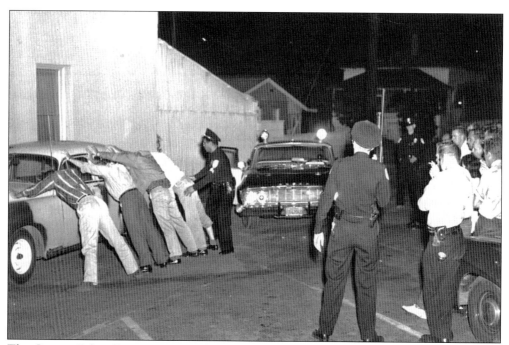

The Corona Police Department conducts a training session for their reserve officers in this photograph taken during the late 1940s.

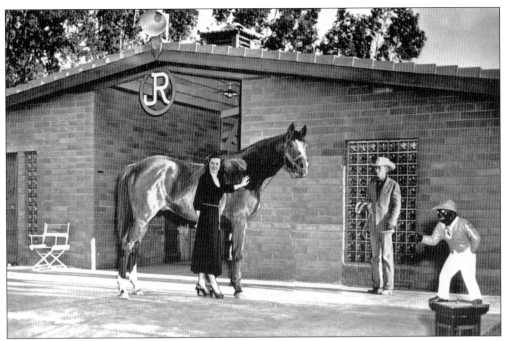

The J. R. Ranch was sold to actor/producer Desi Arnaz during the 1950s. Arnaz renamed it the Corona Breeding Farm, and it became a successful racehorse-breeding venture for him as well as a pleasant weekend getaway from hectic Hollywood. Later, the ranch sold to Dr. E. Jan Davidian and was renamed the Bar-D-Zok Ranch. The property sold once again and in 1985 became the home of the Golden Cheese Factory.

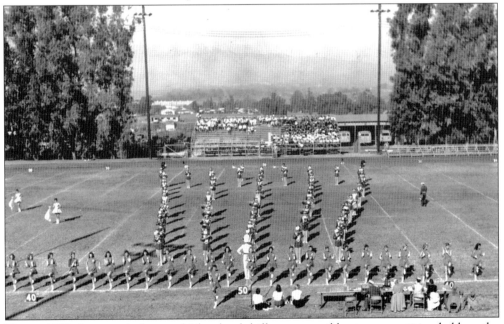

This c. 1950 photograph shows a high school drill team, possibly at a competition held on the football field behind Corona's second high school at 815 West Sixth Street. Corona's new city hall was built on this site and opened its doors in spring 2005.

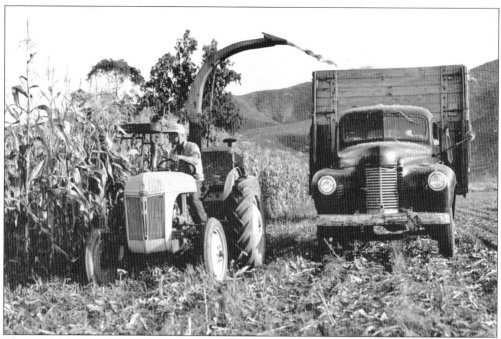

The O. H. Newhouse farm was located south of Home Gardens at Grant and Indiana. A tractor and truck were used to harvest 35 acres of corn. Two crops were raised each year so that the farm would be productive most of the year. In order not to deplete the nutrients in the soil the crops were rotated using corn, black-eyed peas, barley, or oats.

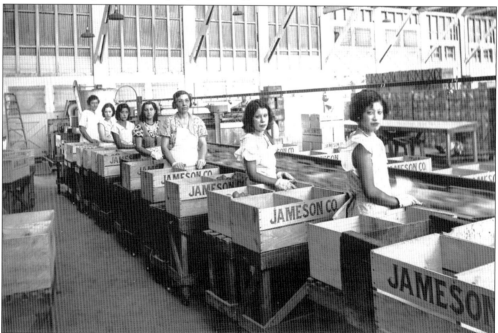

Women at the Jameson Packing House can be seen here in 1948 with an overall-clad man in the background. The Jameson Packing House began operations on Railroad Street west of the Santa Fe Depot in 1913.

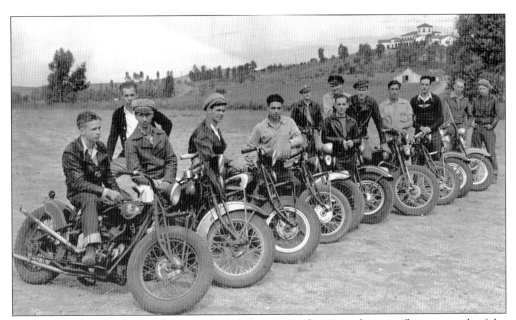

Taken in the late 1940s, this photograph records a group of motorcyclists at a flat area south of the Parkridge Country Club, which can be seen in the background. The Cresta Verde Golf Course and surrounding homes are now found in the hills where the country club was once located.

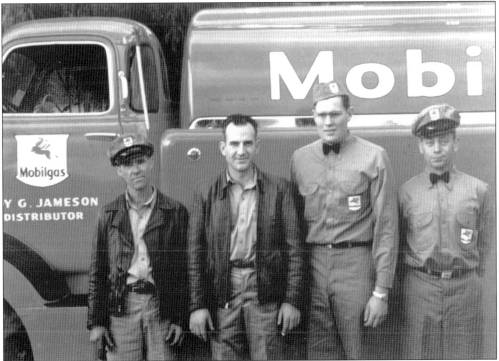

From left to right, Dillard Lockwood, A. J. Hopkins, David Jameson, and Sam Markowitz stand in front of a Mobil gas tanker truck from the Jameson distribution company in March 1949. The business was initially started to deliver fuel to the local groves. In subsequent years the company expanded and deliveries were made to other Southern California areas as well.

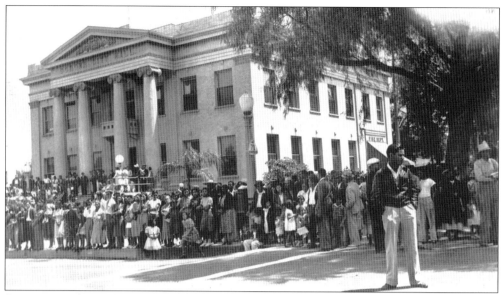

Spectators gather in front of Corona's first city hall at the northeast corner of Eighth and Main Streets for a Cinco de Mayo Parade sometime in the late 1930s. This grand neoclassical structure was built in 1912 and demolished in 1962 shortly after the city offices moved to 815 West Sixth Street, the former campus of Corona's second high school. The architect was Corona pioneer Leo Kroonen Sr.

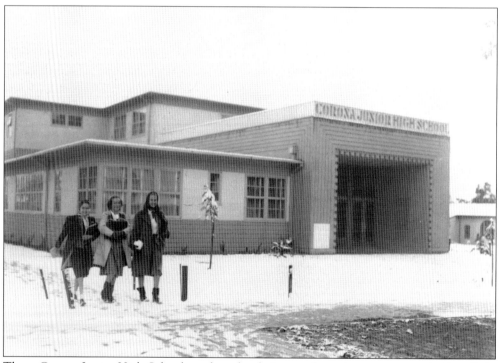

Three Corona Junior High School coeds make their way along the snow-covered sidewalk in January 1949 after a highly unusual snowstorm. This building was added to the campus in the late 1940s. The girl on the right is armed with a snowball and a smile. One wonders if school rules at that time addressed snowball fights.

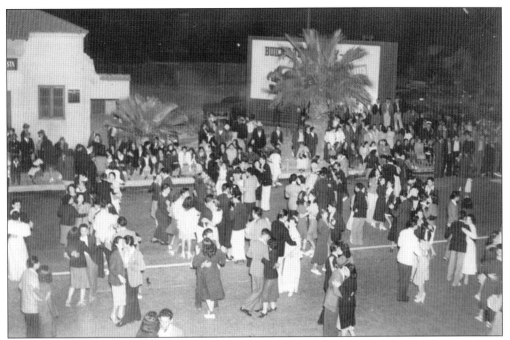

The Mexican Baptist Church celebrates Cinco de Mayo with a street dance in the late 1940s. Main Street was closed between Third and Fourth Streets to accommodate the celebration. The church was located on the east side of Main Street.

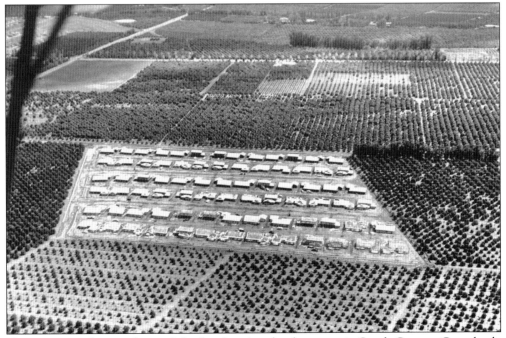

Here is an aerial view of one of the first housing developments in South Corona. Completely surrounded by citrus groves, the perfume of citrus blossoms filled the air of the city that was then known as the lemon capital of the world. Local photographer Rudy Ramos snapped this photograph about 1950, when there were 78 homes on Taylor Street near Ontario Avenue.

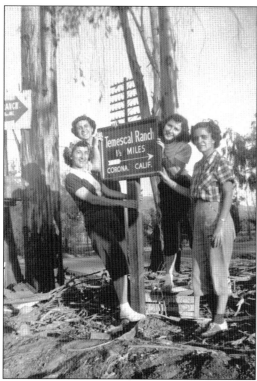

Lydia Panattoni, June Panattoni, Miriam White, and Ruth Panattoni pose by the Temescal Ranch sign, c. 1949. The 400-acre ranch was known as a "model ranch" because of its well-kept groves and production of high-quality fruit. In later years it was sold to Corona Foothill Lemon Company.

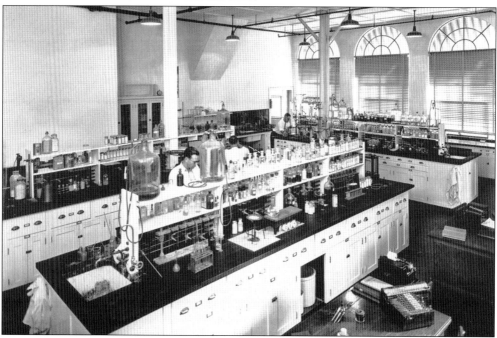

Pictured here around 1950 is the laboratory of the Lemon Exchange Products Company. This business was the first of its kind in the United States and found alternative uses for lemons such as citric acid, lemon juice, lemon oil, and pectin. The company helped save Corona from financial ruin during the Great Depression and ensuing war years.

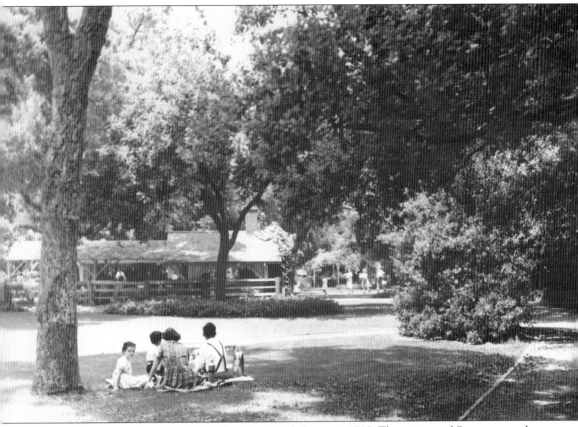

Corona's first city park was established on East Sixth Street in 1913. The citizens of Corona passed a bond for $13,500 and then voted on the park's location. The initial planting of 2,500 trees and shrubs cost $3,600. The park is known for its shady areas for picnics, play areas for children and adults, and as a great gathering place for local community events. The family picnic shown here was held around 1950.

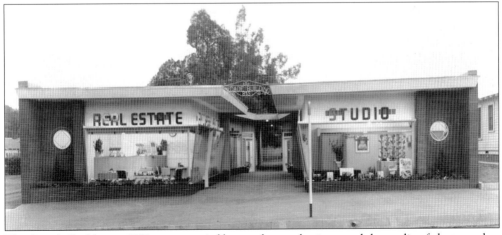

The Arcade Building c. 1950 was occupied by a real estate business and the studio of photographer Rudolph Ramos. Dr. Willard Gills had his office at the left rear of the building and purchased the building around 1950. This structure still stands at 815 South Main Street.

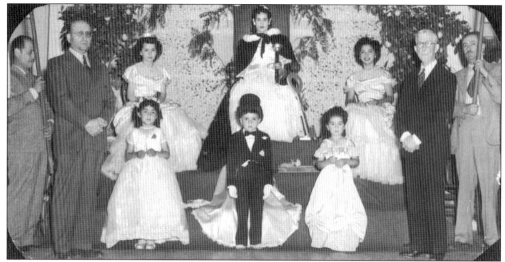

Here is Cinco de Mayo Queen Eloisa Hernandez and her court c. 1950. Mayor Charles Miller is on the right in the black suit. Miller was also the editor of the *Corona Independent* newspaper.

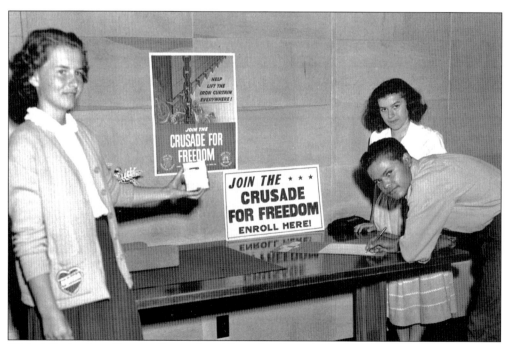

"Help Lift the Iron Curtain Everywhere! Join the Crusade for Freedom" reads the poster in this image taken during the 1950–1951 school year at Corona Junior High School. Dwight D. Eisenhower led the public fund-raising drive for radios to broadcast anti-communist messages to Eastern Europe during the 1950s. During the cold war, Corona students participated in the program, which continued as the "Crusade for Freedom" until 1965.

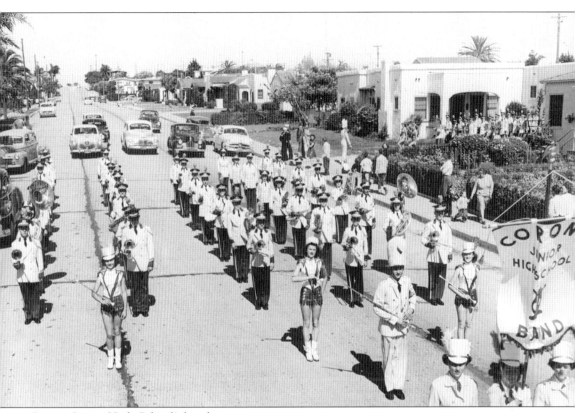

Corona Junior High School's band
provided a lively performance in a 1951
community parade. Leading the band in
the photograph below are Belvia Cropper
(Emerson), Christie Adams, and Beverly
Cropper (Gaven).

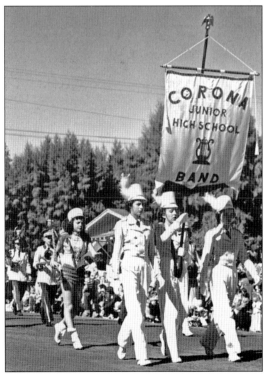

117

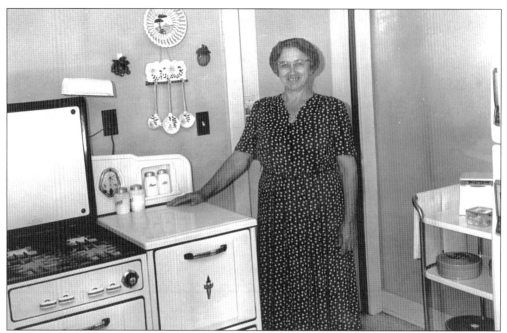

This June 1952 photograph shows Tessie Adamo in her cozy kitchen at 1441 West Sixth Street. Tessie and her husband, Mike, moved to Corona from West Virginia around 1930 and lived there until 1956. Tessie loved to cook and helped out at her husband's shoe repair shop.

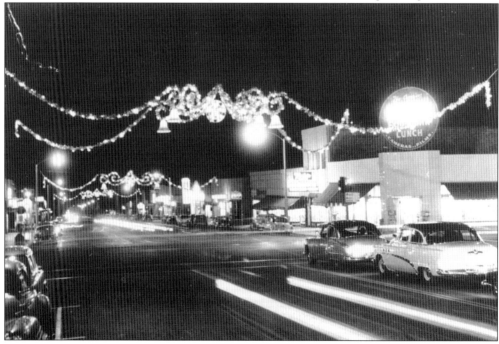

Festive Christmas decorations extend across Main Street looking north from Sixth Street, around 1953. The vintage lampposts that once graced this intersection are no longer present, and signs and awnings have been removed from Cunning's Drug Store. The mileage sign points toward Norco.

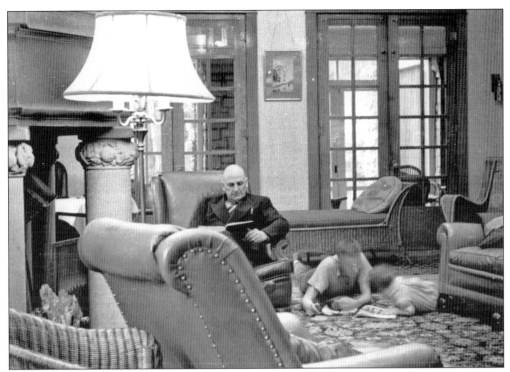

The house at 1127 East Grand Boulevard was built by founding father George L. Joy around 1890. This picture was taken decades later in the living room and shows Clement Joseph Todd Sr. and his children Ted and Helen Todd as they are reading.

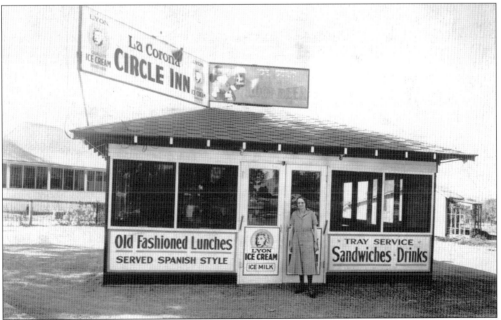

Owner Stella G. Hanna stands outside the La Corona Circle Inn restaurant during the 1930s. This eatery was located at the northwest corner of East Sixth Street and East Grand Boulevard. In the mid-1950s Cupid's Burgers replaced this restaurant.

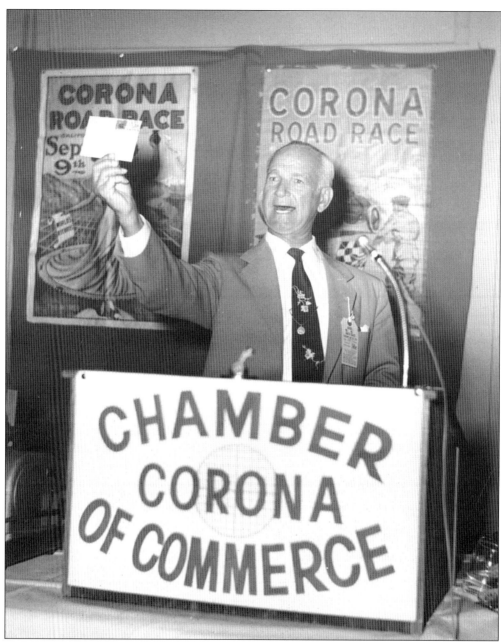

Car racing legend Ralph DePalma, who participated in the 1913 and 1914 Corona Road Races, is shown at a chamber of commerce breakfast in 1954. He had to retire his Mercer after 24 laps in the 1913 race after cracking a cylinder. In 1914 he drove a Mercedes and came in fourth averaging 85 miles per hour. He received a $1,000 prize. DePalma won about 2,000 races in a career that spanned 25 years. After the 1913 Indianapolis 500, his car was sidelined after just 13 laps due to mechanical problems. He is said to have coined the phrase "It's the luck of the game" that day when answering a reporter's question about being sidelined. Note the official Corona Road Race Posters hanging on the wall. The 1913 poster is on the left and the 1914 is on the right.

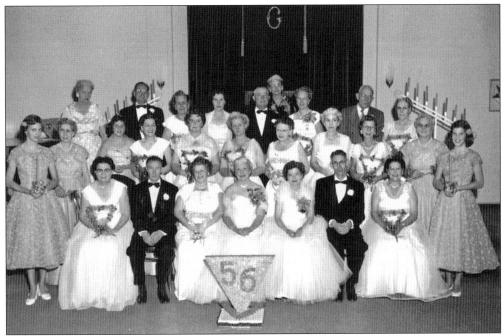

This group picture was taken at an Order of the Eastern Star event held at the Odd Fellows Hall on Main Street in 1956. This men's and women's fraternal organization is committed to helping its members foster charity, truth, and loving kindness.

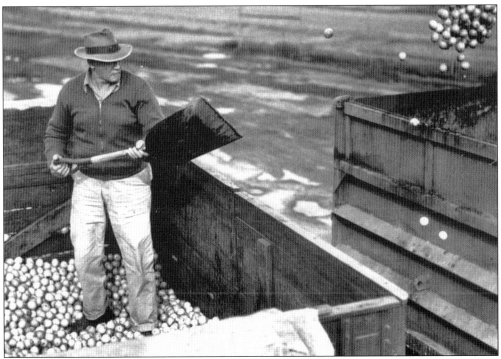

Bill Wilson, one of the original "shovelers" in the citrus industry of the 1930s, demonstrates his technique of transferring lemons from a truck bed to a bin in this photograph from 1957.

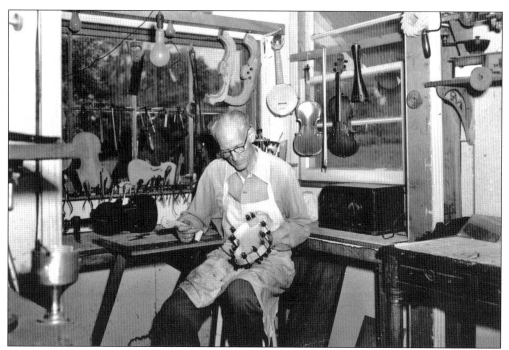

Ethan Allen forms the back of a violin while seated in his workshop in November 1957 surrounded by various other violin parts. By the time this photograph was taken, he had handcrafted 20 violins. Allen previously operated a jewelry store in town for 30 years.

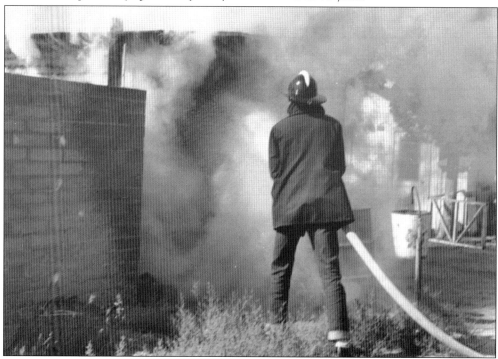

This Corona firefighter is fending off flames and extinguishing a structure fire on June 25, 1958. Notice how his clothing differs from the protective attire worn by firefighters today.

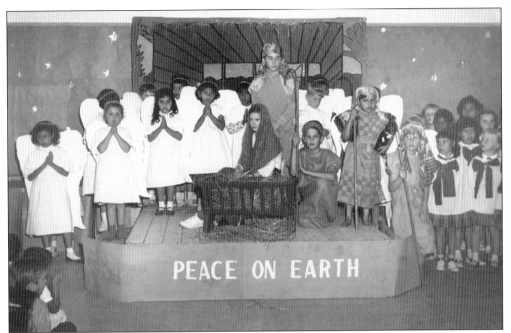

Students portray angels in a 1958 Christmas program at Kimbell Elementary School, located at 308 Buena Vista. This school was named after longtime principal Gladys Kimbell and it replaced the first Washington School, which had been located on West Grand Boulevard between Second and Third Streets.

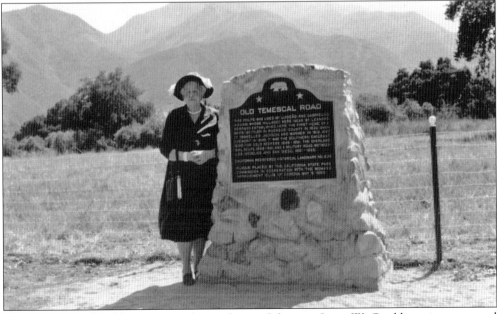

Writer, lecturer, local historian, and great lover of the past Janet W. Gould was instrumental in obtaining state landmark status for numerous sites in and near Corona. In this image, Gould is standing next to the Old Temescal Road Marker, which was placed at the site on May 8, 1959. At the time, she chaired the History and Landmark Section of the Corona Woman's Improvement Club.

Local history buff Howard Ware is seen here examining old photos of the Corona Road Races. Ware enjoyed collecting historical photos, information, and oral histories and served on the Corona City Council from 1930 to 1934. The Ware family established Corona Lumber at Fourth Street and Main in 1904. The business remained active in Corona for approximately 86 years.

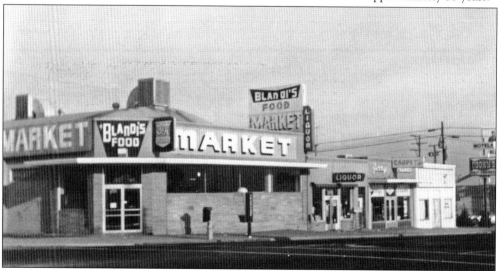

The popular Blandi's Food Market stood at the northwest corner of Fourth and Main Streets for over 46 years. Other identifiable businesses shown in this early 1960s photograph are Mike's Liquor Store, Jerry and Frank's Carpets, and Cooky's Fine Hamburgers. Blandi's was established by Rosario Blandi, a member of Corona's first group of Italian families. Rosario's son Ross served on the Corona City Council from 1968 to 1976.

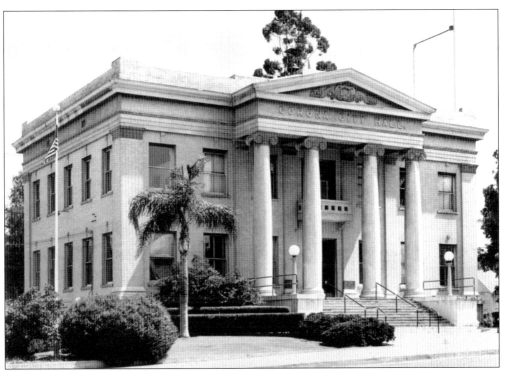

Corona's first city hall was designed by local architect Leo Kroonen Sr. and was built in 1912. Offices for the fire and police departments were located in the basement along with the city jail. It was demolished in 1962 shortly after the city offices moved into facilities at the former campus of Corona's second high school on West Sixth Street.

Shown here is an exterior view at night of Corona's second public library at 650 South Main Street, c. 1971. This building replaced the original Carnegie Library, demolished in 1978. The 19,000-square-foot structure had underground parking and held some 53,000 books in its collection.

Kazoos, tin pans, and washboards were just a few of the instruments seen in this 1962 photograph of Corona's Rebekah Lodge Band performing during a local parade. On the float is a banner noting the 70th anniversary of the Odd Fellows in Corona. Director Alice Tuthill is seated in front with the number 36 on her sleeve. The Rebekah Lodge is the women's auxiliary of the Odd Fellows fraternal organization.

This Remington Rand Univac-60 computer filled the computer room at the Exchange Lemon Products Company c. 1960. Note the input card reader in the foreground. This computer was state-of-the-art at the time and handled the data processing and payroll needs of the company.

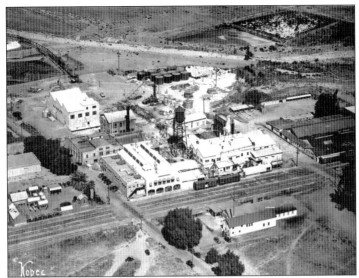

These aerial photos are of the Exchange Lemon Products Company plant. The upper photograph was taken around 1930 and shows a close-up of the arched portico that faces the Santa Fe railroad tracks with Joy Street on the left and Pearl Street on the right. The lower image was taken on January 24, 1964, after Sunkist merged with Exchange Lemon Products Company in 1954. It shows the plant with fields and mountains in the background. The area being graded at the top right of the photograph was for the Cresta Verde housing development and golf course where Parkridge Country Club was once located.

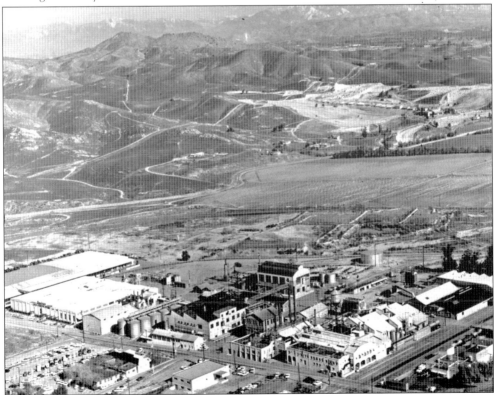

EPILOGUE

During the 1960s and 1970s, all of Southern California began to grow rapidly, as did Corona. The year 1961 brought the SR-91 freeway to town, and affordable housing and freeway accessibility attracted new residents. The City of Corona moved its offices into the historic Mission/Spanish Colonial Revival buildings of the former Corona High School at 815 West Sixth Street. Golf courses and parks were established.

Downtown Corona underwent controversial urban renewal in the late 1960s and early 1970s. Razing the old and putting in new buildings changed the appearance and makeup of the downtown but this did not influence people's decisions to move to Corona or not. During the 1970s, a moratorium on housing was declared while necessary water and sewer systems were developed to keep up with projected growth. By 1980 Corona was still classified as a rural community with a population of 37,791. The "Boom of the 80s," however, was just around the corner and was to prove reminiscent of the boom that had transpired a century earlier.

Housing construction took off between 1980 and 1990. The population more than doubled when it jumped to 76,095. By 1989, the completion of the Interstate 15 freeway became a reality and the developments of Sierra del Oro, Corona Hills, and South Corona expanded rapidly. In 1993 the MetroLink Station was completed providing readily accessible rail transportation into Orange and Los Angeles Counties. By 1996, Corona's population was over 100,000.

With the dawn of a new century came a new designation as Corona was reclassified from a rural community to a midsize urban community. By 2005 and as a result of annexation, the city comprised 24,666 acres and the population soared to approximately 142,000. There were 34 parks, 8 private schools and 33 public schools. A new city hall was built on Vicentia Avenue and opened its doors for business in spring 2005.

Corona has progressed from a few men with a vision and a circular road in the desert foothills to a citrus-based agricultural empire and today is the commercial hub of western Riverside County. It is a thriving community of hard-working residents. Two unique characteristics, however, still set Corona apart from other local cities: the circular Grand Boulevard and the small town warmth and charm that still remains despite the increases in acreage and population.

It is hoped that this book has been able to provide a feel of the history and the people, the places and the events that have made Corona the city it is today.